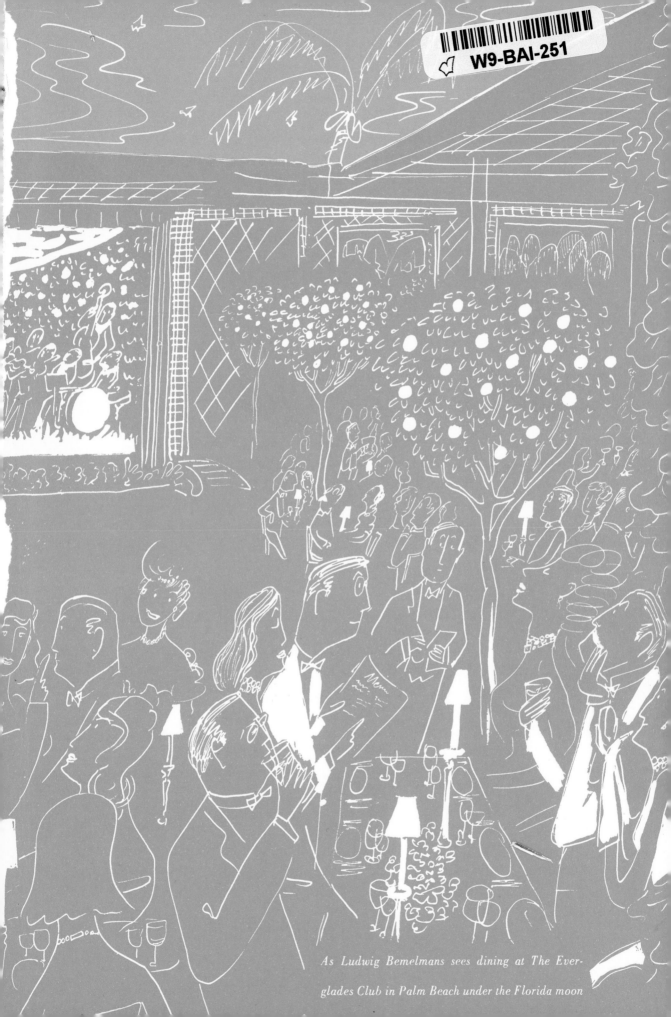

As Ludwig Bemelmans sees dining at The Ever-
glades Club in Palm Beach under the Florida moon

IN THE SPIRIT OF
PALM
BEACH

Date: 1/28/13

For Colt, with deep love and tremendous gratitude for being in my life, by my side, and in my corner.

© 2012 Assouline Publishing
601 West 26th Street, 18th Floor
New York, NY 10001, USA
www.assouline.com
ISBN: 9781614280606
Endpages: Illustration by Ludwig Bemelmans of the Everglades Club, Palm Beach,
Town & Country magazine, January 1955.
© Ludwig Bemelmans, LLC. Used under license. All rights reserved.
Color Separation by William Charles Printing
Printed in Turkey

PAMELA FIORI

IN THE SPIRIT OF
PALM
BEACH

ASSOULINE

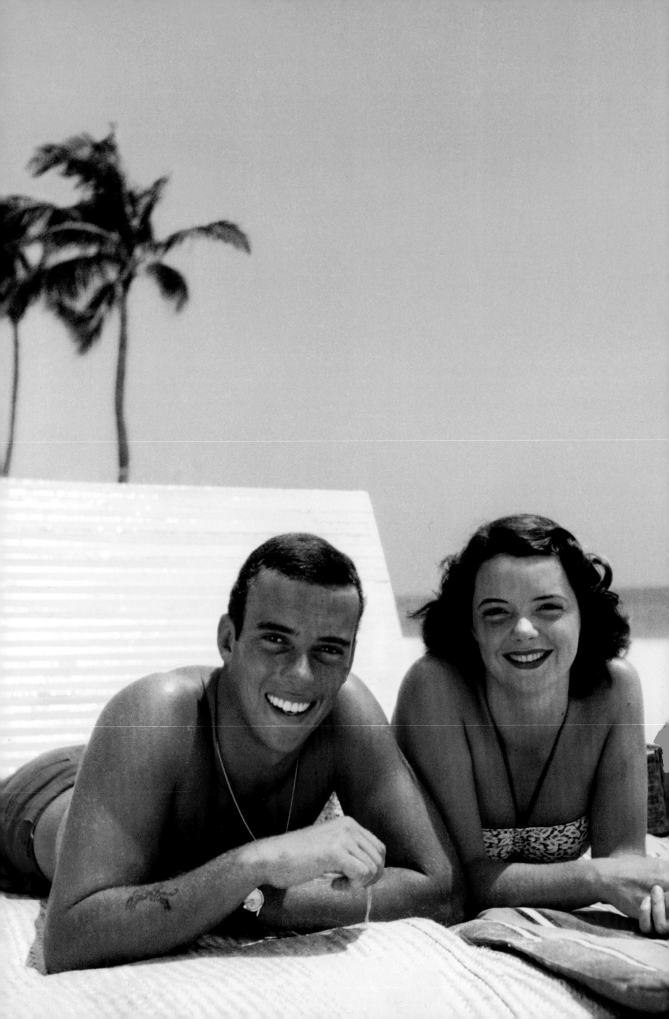

Contents

The Golden Couple: Peter Pulitzer, grandson of press magnate Joseph Pulitzer, and his wife, Lilly Pulitzer, in Palm Beach, 1955.

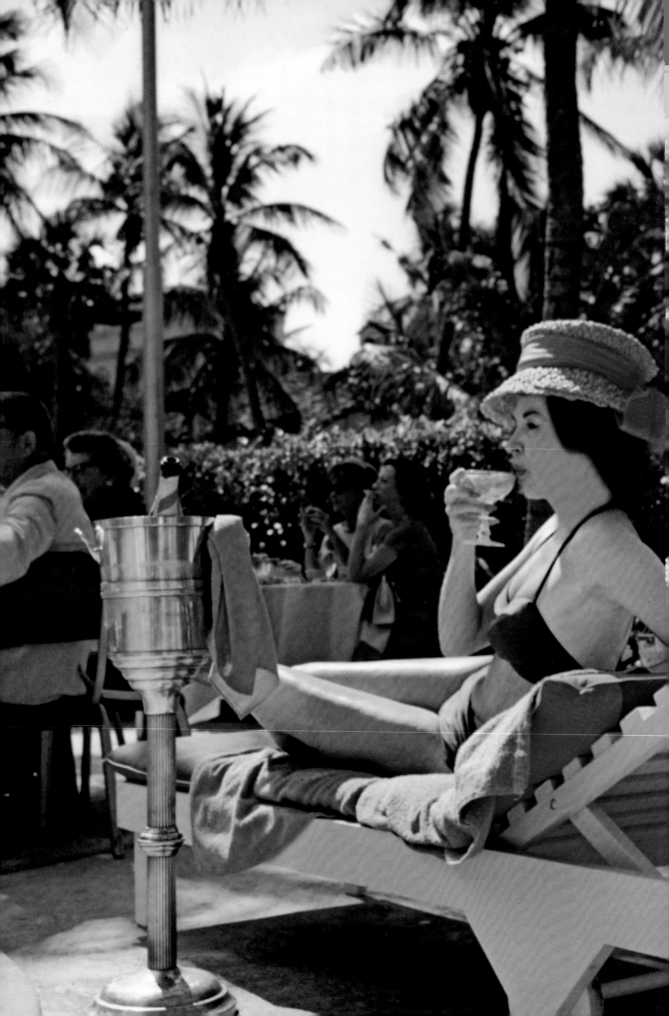

Introduction

If there is one resort community in America that signifies enormous wealth, unparalleled exclusivity, and unmitigated extravagance, it is Palm Beach. Two little words: "palm" and "beach." When combined they conjure up a benign image of nothing more than tropical trees, a deserted expanse of sand, and the soft sound of lapping surf. How sublimely simple. In truth, that's pretty much what Palm Beach was before the arrival of its modern-day settlers and until a certain Henry Morrison Flagler, a founder of Standard Oil, cast his canny eyes on the island's oceanfront acres in the early 1890s and bought them for $300,000. There's something to be said for visionaries who know what people want before they know it themselves. For Flagler, it was a retreat where the rich could go to escape the bone-chilling winter elsewhere.

Palm Beach is an island unto itself, and a small one at that: all of sixteen miles long. Therein is a powerful concentration of wealth. What used to be called "a mecca for millionaires" is today more like a bastion for billionaires, and is as separate and unequal from the rest of Florida as Manhattan is from the rest of New York State. Like the

Woman watching a poolside fashion show at the Colony Hotel in Palm Beach, 1961.

Hamptons, especially Southampton, which is Palm Beach's closest social and cultural equivalent, the island is regarded with both awe and disdain. As with most enclaves, those who are warmly accepted like it just fine, while newcomers and outsiders have mixed feelings or even contempt.

Whatever one's attitude toward Palm Beach, there's no denying several truths: It's breathtakingly beautiful, squeaky clean, and as secure as a fortress. At the same time, anybody can go there; there aren't entry gates or moats. Everything about Palm Beach is scrupulously maintained—the estates, the public buildings, and its reputation as affluent America's premier playground. The tourists Palm Beach attracts are not your usual suspects. For example, the well-heeled crowds that the town draws in are already experts in the public dress code. After all, there are rules in Palm Beach, many of them unwritten but understood by the cognoscenti.

Oddly, for a place so synonymous with elitism, Palm Beach can be truly hospitable, especially in the hotels, restaurants, and shops. At The Breakers, Palm Beach's oldest existing and most esteemed hotel, the staff is unfailingly friendly (and capable). Go into any restaurant and you'll feel welcome—more so if you have a reservation. Do a little shopping and the salespeople will seem glad to see you, with no hard feelings if you leave empty-handed. Stroll down almost any street and people will give you a neighborly "hello" (unless, that is, you look as if you don't belong there because you're not adhering to the aforementioned dress code). And while some of the grandest houses are hedged up to within an inch of their property, others are exposed in all their glory for all to ogle and admire.

On the other hand, the private clubs—and there are many—are just that: private and not for entering. Certain subjects (like the qualifications for membership) can cause uneasiness, and may even be met by silence. And unless you are a Palm Beach habitué or a visiting VIP, you're unlikely to be invited to somebody's home. For those who aren't part of the coveted inner circle, sensitivities can be high, even to the point of overreaction. One man sheepishly recounts his visit to Palm Beach: "I was invited to a wedding at the Everglades Club. As I was pulling into the driveway, there was a car in front of me, which was waved in. After a momentary hesitation, so was I. During the reception a woman introduced herself and said, 'I'm the one who got you into the club.' I thought she was referring to my being Jewish. It bothered me for days. Then I realized that all she meant was that she was ahead of me and merely paved the way for me to pull in. In retrospect, I was mortified."

Mar-a-Lago, the onetime estate of Marjorie Merriweather Post and now owned by Donald Trump, is the Every Rich Man antidote to the Everglades and the Bath and Tennis Club. Others—the Palm Beach Country Club, the Sailfish Club of Florida, Club Colette, the Beach Club, et al.—fill in other social gaps.

Across the three bridges that connect Palm Beach with the mainland is West Palm Beach, a city that's proletarian and proud of it. Built as a service town to house the workers of Palm Beach's early resorts, West Palm Beach today is dotted with antiques shops and consignment stores. Many Palm Beachers like to go there to check out the wares on South Dixie Highway; shop in places like Gap, Banana Republic, Macy's, Barnes & Noble, and Bed Bath & Beyond; and perhaps just relax and breathe less rarefied air for a change.

Palm Beach will never be fast, loose, and sexy like Miami. But it is far less insular than it used to be. The demographics are changing, and many recent arrivals are no longer just wealthy WASPs. Nearby, Tequesta, Jupiter, Delray Beach, Gulf Stream, Boca Raton, and Wellington all encourage diversity. In that regard, women in Palm Beach have famously wielded political power there in recent years (and staying power—many live to well into their nineties); both the current mayor, Gail L. Coniglio, and one of her predecessors, Lesly Smith, are female. And in 2011, Mayor Coniglio oversaw the celebration as the Town of Palm Beach marked its centennial. The milestone was commemorated with much fanfare, and for good reason: The city really did rise from a few palm trees and several trillion grains of sand.

During "the Season"—which runs from Thanksgiving to Easter, or late April—Palm Beach is a busy hive, tables in the top restaurants are hard to get, hotel rooms are booked, and traffic is snarled. There's a party somewhere every night. But even in the off-season, Palm Beach is a pleasant place to be if you don't mind the heat. And if you do, there's plenty of air-conditioning to go around.

As sheltered as Palm Beach is, it has not been safe from scandals, swindlers, and its share of shameful episodes. In the 1920s, Paris Singer, heir to the sewing-machine fortune, had a famous fling with the dancer Isadora Duncan. In 1991, William Kennedy Smith, of the Kennedy clan, was charged with rape, then later found not guilty after a well-publicized trial. In 2008, Bernard Madoff made off with other people's money—and landed in prison for perpetuity. Most recently, John Goodman, the Texan playboy founder of the International Polo Club Palm Beach in Wellington, was convicted of manslaughter in a DUI case that resulted in the tragic death of a 23-year-old local man.

But while there have been sexual dalliances, mysterious goings-on, and other mayhem in and around the community since its inception, Palm Beach has prevailed. Is this little piece of paradise for everyone? Decidedly not. Nor does it aim to be. If it did, Palm Beach wouldn't be what it is—a ravishing and unapologetic embarrassment of riches.

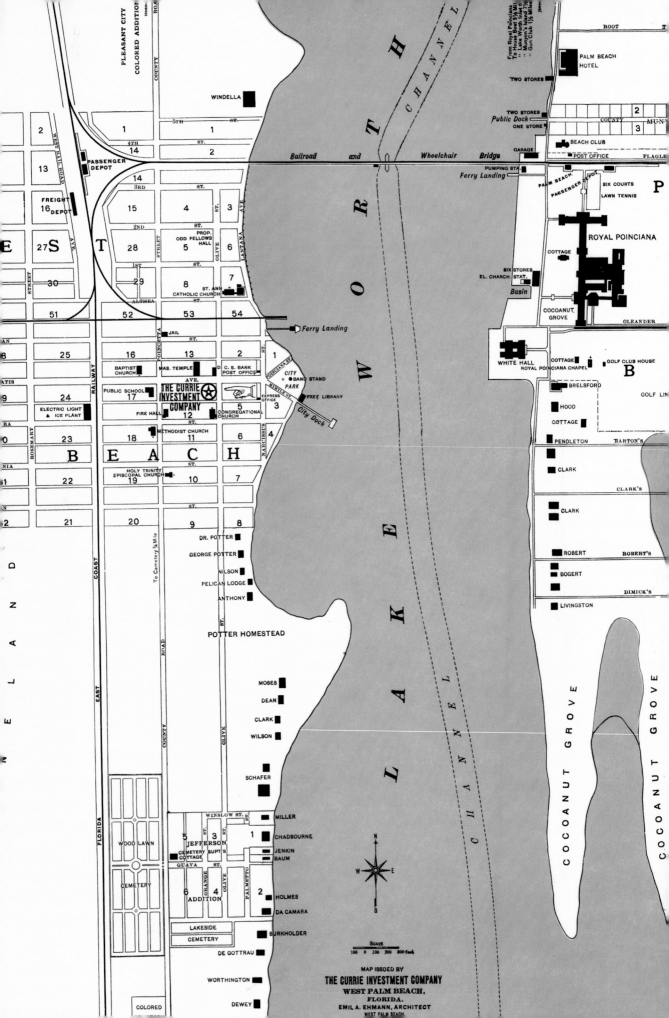

MAP ISSUED BY
THE CURRIE INVESTMENT COMPANY
WEST PALM BEACH,
FLORIDA.
EMIL A. EHMANN, ARCHITECT
WEST PALM BEACH.

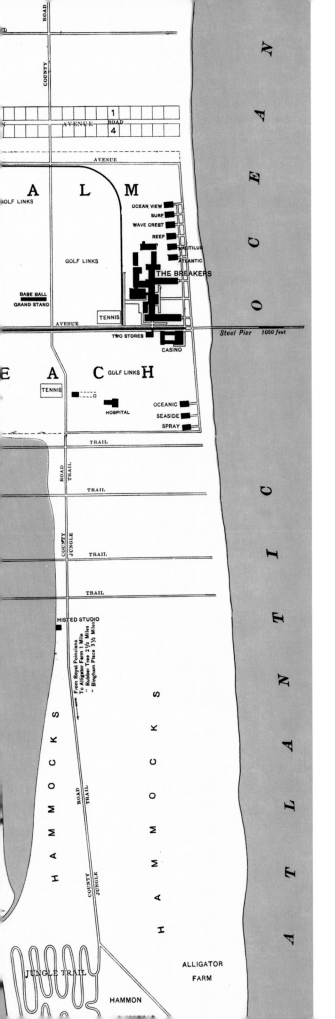

In the Beginning

*All Palm Beach is a memorial to
the incredible imagination and
energy of Henry Morrison Flagler,
who knew how to give the rich what they
wanted and who knew, too, that if you were
to charge enough, Society will go anywhere
and smilingly pay the tab.*

W. A. Powers, *Town & Country,* February 1962

Were it not for a shipwreck on January 9,
1878, on Florida's southeast Atlantic Coast,
there might not be a Palm Beach as we know
it at all. The *Providencia,* a 175-ton Spanish brig,
ran aground with a cargo of 20,000 coconuts,
along with a supply of wine, cigars, and other
provisions. The ship, which had begun its
voyage in Havana (the coconuts were from a
stopover in Trinidad), was en route to Cádiz,
Spain. It's not clear why the wreck happened;
some speculated that the captain and crew
crashed the brig to collect insurance money.
In any event, two local homesteaders, Hiram
F. Hammon and William M. Lanehart,
befriended the ship's captain, who gave the
men the coconut cargo, but not before the
locals and crew enjoyed the ship's bounty on

Historic map of Palm Beach from 1907 with a detail of
the Hotel Royal Poinciana and The Breakers. *Following
pages:* Palm trees overlooking pristine blue water.

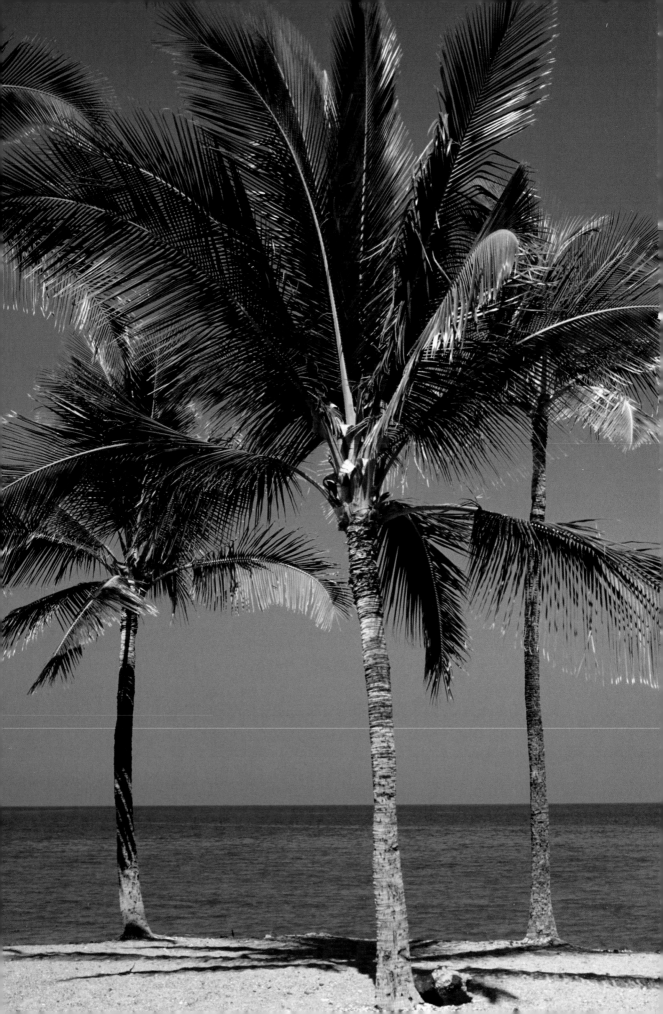

the beach for a fortnight. Hammon and Lanehart sold the coconuts to fellow pioneer settlers, who promptly planted them. And from that humble beginning came the majestic palm trees that would populate—and define—this resort city.

That's not to say that Palm Beach had always been uninhabited. Native Americans had occupied the land for millennia, but were largely gone by the 1700s. The Jaegas, a tribe that lived along the coast of today's Palm Beach County, were among the last indigenous peoples there, eliminated by the usual suspects: disease, warfare, and the slave trade. Enter the Seminoles, who had emigrated from other parts of the South. During the First Seminole War, in 1818, the tribe fought, and was defeated by, the U.S. Army under General Andrew Jackson.

In the 1860s, a Confederate soldier who had deserted the army found his way to southern Florida, built a shack, and did some planting, which, after the wreck of the *Providencia,* included a few coconuts. More pioneers followed after the Civil War and settled along the coast. Early on, the entire area was called Lake Worth Colony. The lake was named for Major General William Jenkins Worth, who fought in the Second Seminole War (1835–1842) and the Mexican-American War (1846–1848). The settlers lived off the land and scavenged whatever treasures they could find from shipwrecks. But it was the *Providencia's* trove that paved the way for today's paradise.

Other names had been considered for Palm Beach by the founding settlers: Tustenegee, after a Seminole Indian for whom the post office was first named, was rejected, as was a second choice, Palm City, which was already the name of another Florida town. The third, Palm Beach, stuck.

In the early days there weren't any places to stay until an enterprising resident, Elisha ("Cap") Newton Dimick, added eight rooms to his Lake Worth home in the early 1890s and began accepting guests. It eventually grew to fifty rooms and was called the Cocoanut Grove House, charging six dollars a night for room and board. Unfortunately, the Cocoanut Grove House, made mainly of wood, was destroyed in a fire several years later. Among his other contributions—he was the Town of Palm Beach's first mayor and started the city's first bank—Dimick, with his inaugural Palm Beach lodging, set the stage for the next man who would make his indelible mark in the island's sand.

The man's name was Henry Morrison Flagler. Once John D. Rockefeller's partner at Standard Oil, Flagler decided to swap oil for soil and became a real-estate developer. He had his eyes on a prize: Florida's southeast coast. This part of the state was flat, swampy, and not considered to be of much value. Flagler was able to see beyond what was there, to what Palm Beach could be. What the area lacked in natural resources, it more than made up for with its warm and (mostly) sunny climate. Many people back then thought Flagler was out of his mind. The jokes about the earnest sap buying swampland that no one else wanted were legion. Flagler, however, was nobody's fool. Crazy like a fox was more like it, and a man who knew how to give the rich what they

Evelyn Walsh McLean and her son, circa 1913. *Following pages:* The Hotel Royal Poinciana, Henry Flagler's first hotel in Palm Beach, circa 1900.

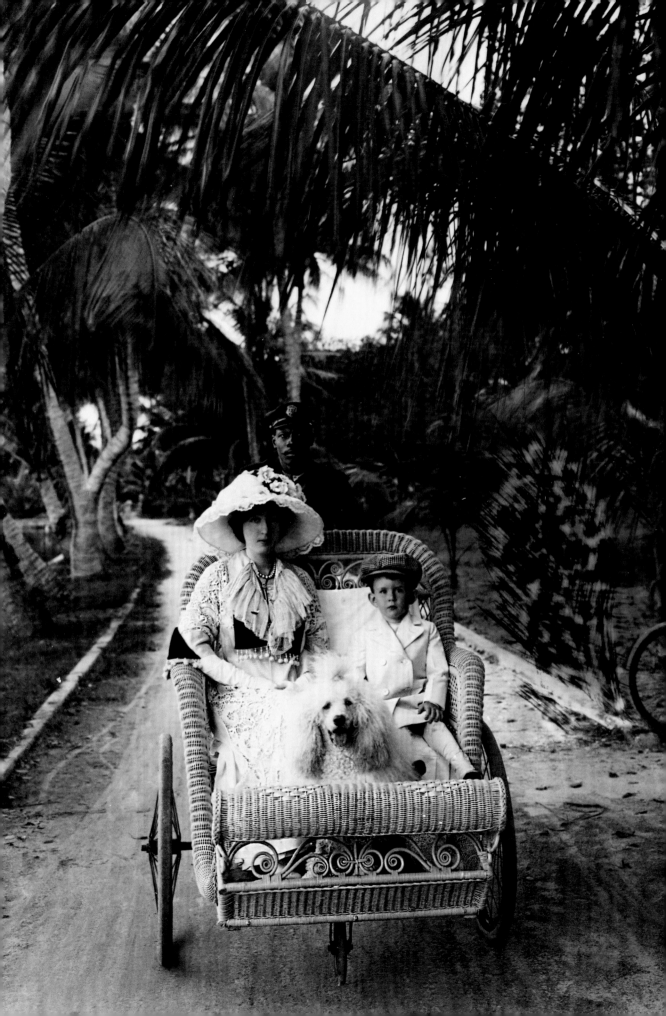

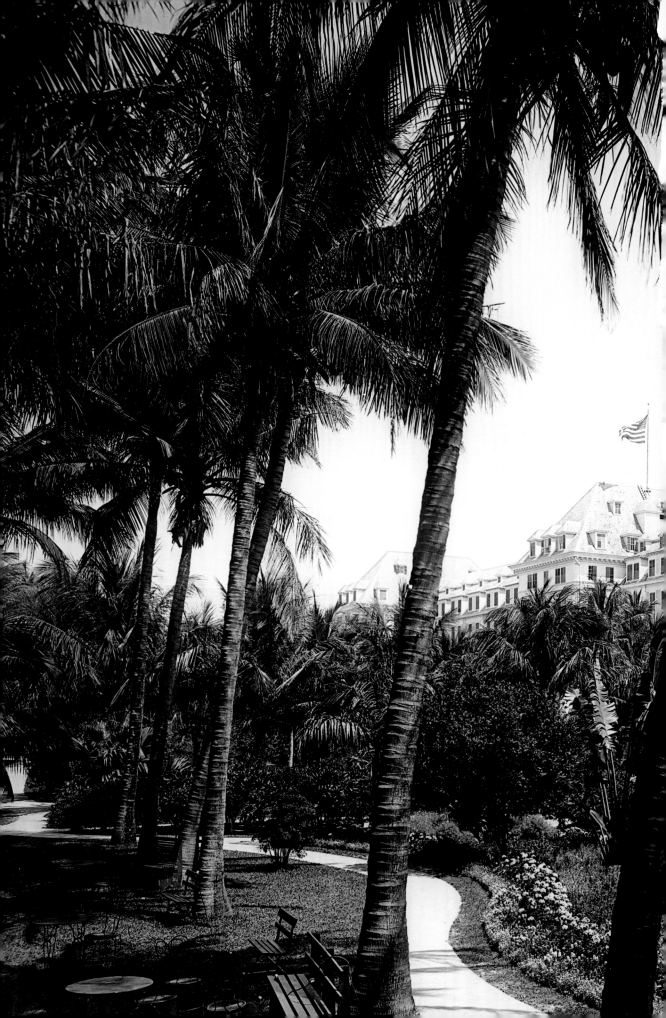

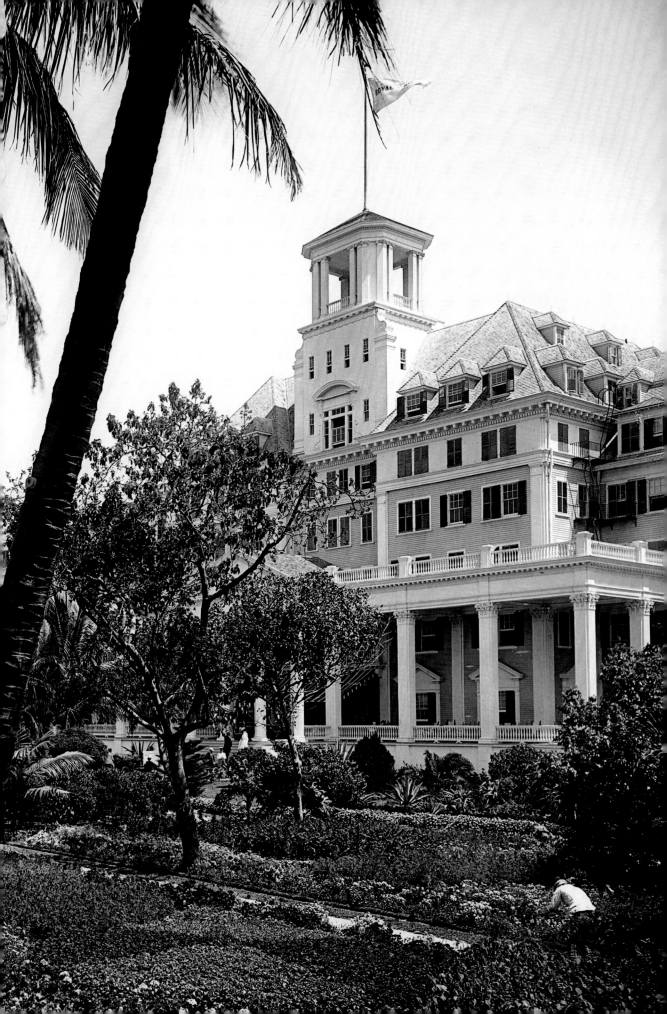

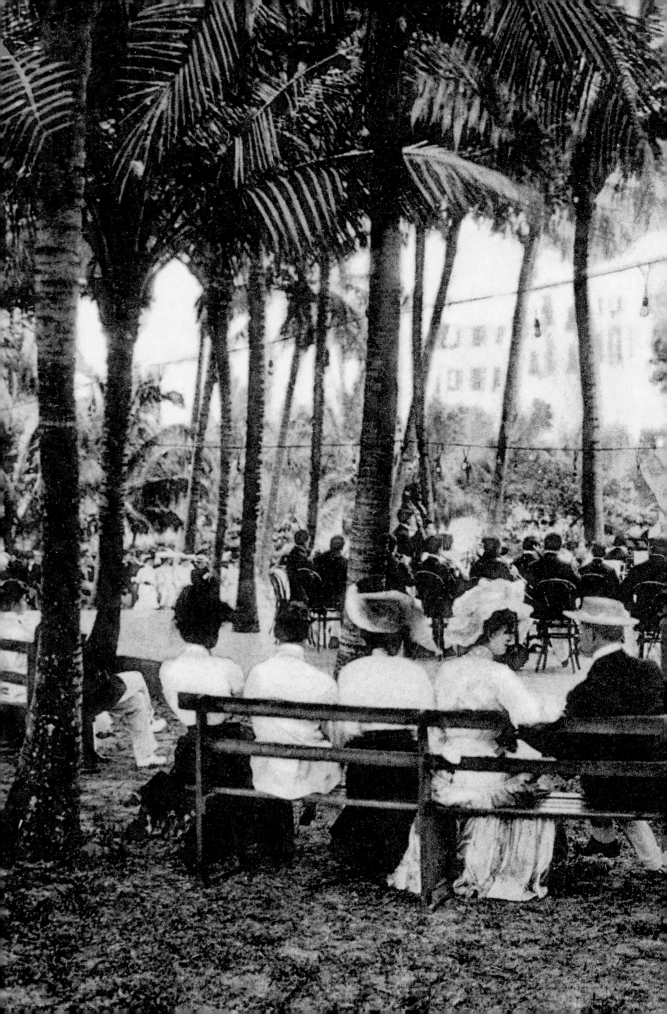

wanted. He also knew that if you charged enough, Society—with a capital *S*—would go anywhere and smilingly pay the tab. To test this out, he went farther south in Florida.

For his next venture, Flagler plunked down what was estimated at $300,000 for one hundred acres and began to sketch out a plan to create a second-to-none establishment. Wealthy members of the East Coast establishment would now have a place "to winter." To accomplish this, he spearheaded the creation of the Florida East Coast Railway, a line that would eventually run the length of the state. The Hotel Royal Poinciana opened in 1894, and two years later, the train arrived at the hotel's front door.

Flagler hoped to lure the so-called first families of America—the Astors, Phippses, Van Rensselaers, Carnegies, Rockefellers, and other American blue bloods—to his new hotel. And he succeeded: The Hotel Royal Poinciana accommodated more than seventeen hundred guests at a resort that covered thirty-two acres. Most of the guests knew—or knew of—one another, and soon the rich were flocking *en famille* to Palm Beach in their finery and with entourages. In *The Last Resorts*, Cleveland Amory's 1952 portrait of social playgrounds, the author recounts the inaugural rail trip. "The first train to cross Flagler Bridge to the Poinciana on March 14, 1896, bore a shipment of no less than four Vanderbilts—out of a total of seventeen passengers. The train was not only a private-car affair but also an entirely private train."

Afternoon tea in the Cocoanut Grove at
The Breakers, 1904.

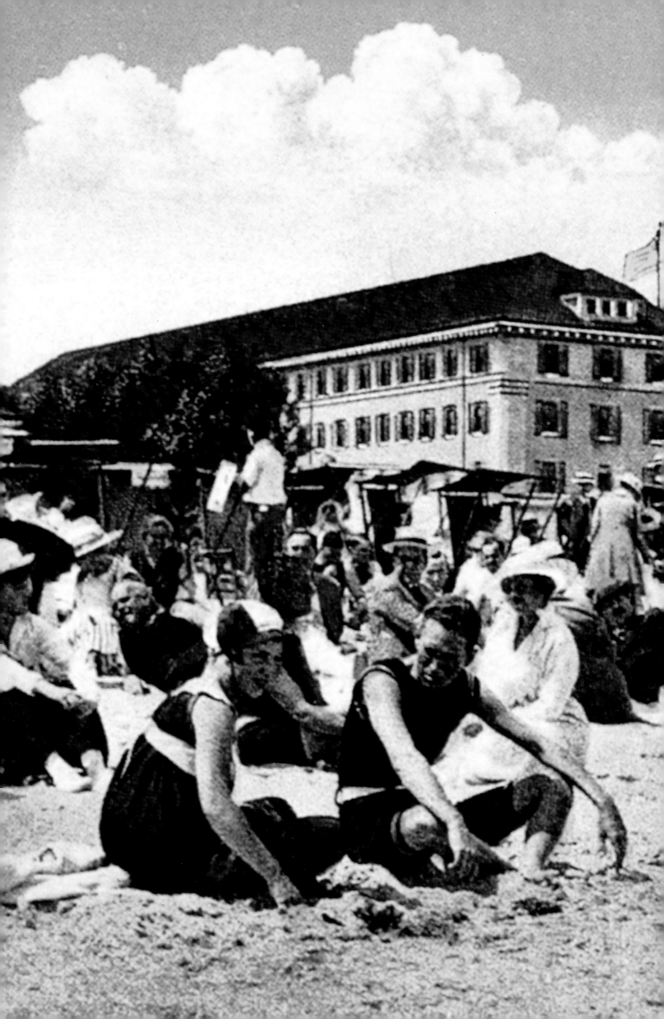

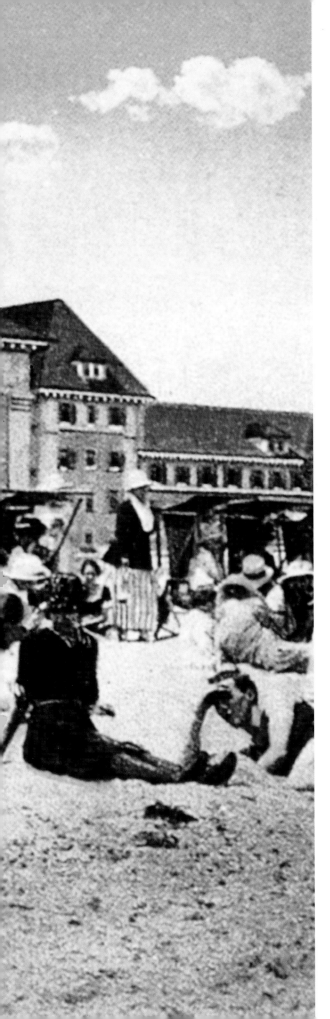

Splendor in the Sand

The Breakers Hotel is notably a home, not a hostelry in the ordinary acceptance of the word. Year after year, the same people slip into the same suites, meet in the same corner of the rotunda, play the same games, and have the same general good time.

Palm Beach Life, January 12, 1907

Grand hotels and grande dames have a great deal in common. Both are revered for their imperious bearing and their beauty—often faded, but still discernible. If fortune smiles upon them, they age gracefully. They usually have a glamorous past, a commanding presence, tales to tell, and secrets to keep. As for upkeep, they are high maintenance to the nth degree.

The difference between them is that grande dames eventually pass away, while the fate of grand hotels is less certain. Some fall on hard times and shutter their doors. Others may sputter for years, landing in the hands of this or that owner, or morphing into new renditions until they're virtually unrecognizable. A precious few live on—altered or updated along the way out of necessity, but not so radically that they lose their luster. The Breakers is just

The beach scene at The Breakers hotel during the early twentieth century.

such a rarity. That the resort hotel is strategically and magnificently located on prime oceanfront acreage in a city long known for its grande dames is probably no accident. The Breakers, however, has outlived most of them—and outshines them all.

Of Henry Morrison Flagler's many achievements—among them, his breakthrough development of Florida's Gold Coast and his successful partnership with John D. Rockefeller at Standard Oil—he might well have considered The Breakers to be his crowning glory. The trouble is, Flagler didn't live long enough to see it, at least not in the hotel's modern state, which is a pity, for he no doubt would have burst with pride that the inn he opened in 1896 as an annex to his much grander Hotel Royal Poinciana would become Palm Beach's architectural centerpiece, and it never would have existed if not for his vision.

Since its inception, The Breakers has occupied prime oceanfront land in Palm Beach. But in its third incarnation, in 1926, this time by the New York architecture firm of Schultze and Weaver, it could just as easily have graced the hills of Tuscany. Indeed, most everything in the design of the hotel was either brought back from or inspired by Italy—especially the Italian Renaissance—and elsewhere in Europe. The facade takes its cue from the sixteenth-century Villa Medici in Rome, and the fountain in front of the entrance was modeled after the one in the Boboli Gardens in Florence. The Great Hall of the Palazzo Carrega Cataldi in Genoa was the inspiration for the hotel's cavernous lobby, its barrel-vaulted ceiling a fantasy of frescoes that were hand-painted by seventy-five Italian artisans. And every few feet, there are comfortable seating arrangements where guests can perch and watch—what else?—their fellow guests. Everywhere you look, there are loggias, promenades, patios, and courtyards—large and small. The ballrooms, three in all, are rich with ornate moldings, oversize marble fireplaces, antique mirrors, and opulent furnishings. If all this sounds like too much, rest assured, it suits Palm Beach—which never saw a replica it didn't like—to a tee.

As significant as The Breakers would be to Palm Beach, for Henry Flagler it was something of an afterthought. The genius developer's focus was initially on the Hotel Royal Poinciana at Lake Worth, which he unveiled in 1894 as the biggest luxury hotel in the South. It was a six-story wooden structure, the largest of its kind, painted a bright yellow, with 540 rooms. As the hotel was added on to, it could accommodate nearly three times that number.

The Breakers, first named the Palm Beach Inn, opened two years later. It was smaller, quieter, and right on the beach, where guests could watch the waves break—hence, its new name—along the shoreline of the Atlantic Ocean. (By the way, the hotel is not to be confused with the Breakers mansion in Newport, Rhode Island, which was built around the same time, for Cornelius Vanderbilt II.)

slacks for women. At the breakfast buffet, we children were taught how to serve ourselves and not to overdo it at a reception." That's progress. Once upon a time, children weren't even allowed in the dining room for dinner.

These days, children are not only permitted, they're welcomed. The lobby and hallways are abuzz, but instead of running into elderly people with walkers (granted, you'll see a few), you're more likely to encounter infants and toddlers in double strollers being pushed by their parents or nannies. As part of a carefully conceived plan, The Breakers is now a destination of choice for younger, affluent families, which includes wealthy Americans as well as their European and South American counterparts.

Not all has run smoothly at the hotel. The Breakers took a dip in the early 1980s, and for all its grandeur, was behaving like a middlebrow chain hotel without a future. It lost not only its luster but also recognition from critics and organizations that bestow awards of excellence.

No doubt about it, The Breakers was on the brink. A decision had to be made on the part of its owners: Sell it or keep it. To keep it—and to do so prosperously—required more than maintenance. It meant making a huge commitment to invest money in the property and once again produce a world-class hotel. That's the road the owners decided to take.

The Breakers' owners today are the Kenans (pronounced Keenans), a low-key, old-line North Carolina family who are descendants of Henry Morrison Flagler's third wife, Mary Lily Kenan. Since Henry Flagler's death in 1913, and Mary Lily's death in 1917, the hotel has been in the family's capable hands. Sole ownership of a major hotel these days is as rare as private ownership of a media company. And resisting the urge to expand the portfolio is rarer still. To date, there is only one Breakers, and there's no chance that you'll find a sister resort in L.A. or Dubai anytime soon, unless James G. Kenan III, the present CEO, decides to divest the family of the storied property. One conversation with him will convince any listener that this simply isn't in the cards, not as long as he's in charge, that is.

Cannily, Kenan and Paul Leone, the hotel's President, figured out what it takes most American corporations years to learn: that the key to a smooth-running operation starts with the employees. Keep them motivated and satisfied with their work, and everything else will fall nicely into place. Such a neat little idea, but not so easy to pull off.

When it comes to a mantra, Jim Kenan has his own favorite: "Rig for bad weather." In other words, be prepared for any eventuality. Those words proved prophetic in September 2004, when southern Florida was hit by two fierce hurricanes just weeks apart, which resulted in The Breakers' needing to evacuate the property both times and to close its doors for weeks at a time. There was no structural damage, but professional crews were hired to "clean, restore, and refresh"

Guests relaxing on a spacious veranda, circa 1990s.

Unfortunately, the vulnerable wood building burned down not once but twice, in 1903 and again in 1925. (The second fire is believed to have been started by an electric curling iron that belonged to the wife of the mayor of Chicago.) Flagler, who died in 1913 at age eighty-three, would never witness what The Breakers became in its third and current form: a magnificent Italianate palazzo built of reinforced concrete and bolstered by more than a thousand tons of steel—virtually impenetrable and, its builders hoped, both fireproof and hurricane-proof.

The Breakers, which came into existence as the Gilded Age was coming to an end, proved a magnet for the wealthy upper classes. It was grand and formal, and open only "in season" (from December to April) because this was before the advent of central air-conditioning, a necessity in subtropical Florida's hottest months. According to Cleveland Amory in his 1952 book, *The Last Resorts*, "Life at the Royal Poinciana and The Breakers was in those days the closest to an era of simplicity as Palm Beach ever had." That is, of course, if you can call eight-course luncheons, afternoon drives in a wicker rickshaw, teatime on the vast lawn known as the Cocoanut Grove, formal dinners, and dancing afterward in the Grove remotely simple.

What Flagler didn't count on was how much more popular his second hotel would become. Guests preferred it to the Hotel Royal Poinciana because of its size and feeling of intimacy. It also had the advantage of being right on the beach, so guests could swim in their bathing costumes (for women, that meant an all-black outfit that demurely covered the legs and upper torso). Eventually, The Breakers eclipsed its older and larger sister. (The Hotel Royal Poinciana closed in 1934, in the midst of the Great Depression, and was razed the following year.)

After its last resurrection, The Breakers continued in this blue-blooded vein well into the twentieth century, surviving the Depression and serving as a military hospital during World War II, before eventually breaking away from its unwritten "restricted" policy that kept out those who are welcome today. "The airplane made all the difference," says James Augustine Ponce, the hotel's historian for nearly three decades. (A native Floridian, Ponce traces his Spanish lineage in the state to the late 1500s, and claims a family connection to the explorer Juan Ponce de León.) "Before, people came with steamer trunks and stayed for long periods," recalls the courtly nonagenarian, who gives tours of the hotel and also of Worth Avenue, Palm Beach's famed shopping street. "Behavior was very structured in those days. Women put on floor-length gowns to come to dinner, and men were always in coats and ties."

Even into the 1960s, proper behavior was expected, and not just from adults. Lisa Birnbach, author of *The Official Preppy Handbook* and *True Prep: It's a Whole New Old World*, remembers: "I learned a lot about etiquette at The Breakers. When I was a young girl, the lobby had a strict dress code after 5 p.m.: jacket and ties for gentlemen, and dresses or dress

Enjoying an afternoon game of golf. *Following pages:* Breathtaking view of one of the hotel's pools at dusk.

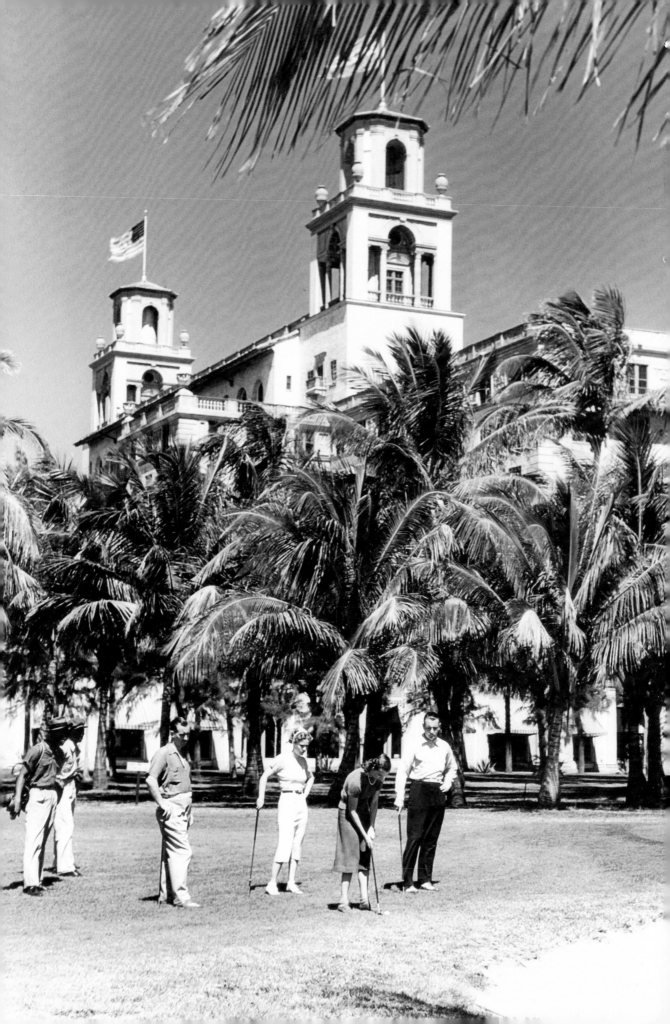

Clockwise from top left: The spacious Mediterranean ballroom at The Breakers features ornate decor fit for an Italian palazzo; the Circle Restaurant is where guests enjoy the celebrated Sunday brunch tradition at The Breakers; exterior view of The Breakers, circa 1950; Henry Flagler, the visionary behind Palm Beach's grandest hotel and its emergence as a playground for some of America's wealthiest families.

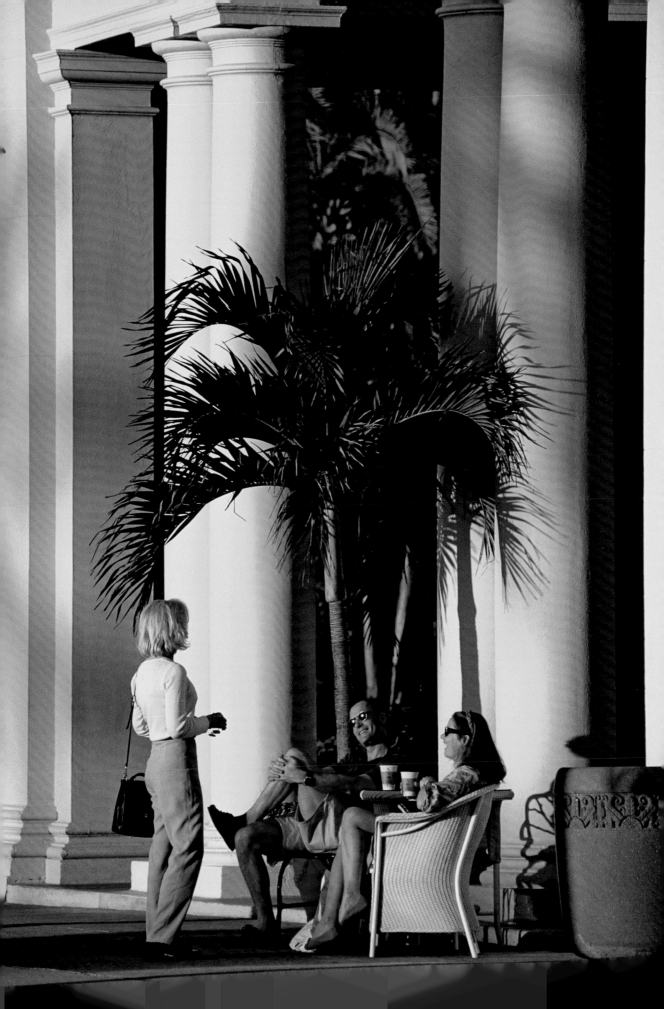

> *"We had a sleeper for the men and a sleeper for the women, a sitting room and a dining car and even a car for our luggage."*

COUNTESS SZECHENYI
YOUNGEST OF THE VANDERBILTS, WHO IN 1896
TOOK THE FIRST PRIVATE TRAIN TO THE HOTEL
ROYAL POINCIANA, *THE LAST RESORTS* (1952)

> *"The things that are old Palm Beach are the things that I like."*

PRISCILLA RATAZZI WHITTLE
PHOTOGRAPHER

> *"On her honeymoon at Palm Beach, she wore so many jewels that she was forced to take along a detective as well as a husband; on a later occasion she did over the entire patio of El Mirasol from midnight to morning while Mr. Stotesbury, who knew nothing about it, peacefully slept."*

MRS. EDWARD T. STOTESBURY
AS DESCRIBED IN *THE LAST RESORTS* BY
CLEVELAND AMORY (1952)

"Palm Beach: not exclusive, but merry sumptuous, and expensive. Chance to meet many men in the gambling rooms."

FROM FRANK CROWNINSHIELD'S
1908 RATING OF EASTERN RESORTS
THE LAST RESORTS BY CLEVELAND AMORY (1952)

"Palm Beach is like a paradise and one of the few places in America where you can not work and not feel guilty about it. There's no work ethic here."

WILLIAM J. DIAMOND
TOWN COUNCIL MEMBER

the property, as the hotel reported at the time. Yet it was the manner in which Jim Kenan handled the disaster that is the stuff of Breakers lore today. You won't hear Kenan boasting about it—that's not his way—but others will tell the story of how he insisted that the employees be paid their full wages until the hotel reopened for good (six weeks after the first hurricane hit), for no other reason than he felt it was the right thing to do.

Over the past decade, with $250 million invested in infrastructure, room renovations, and additions to the property, The Breakers, once again, is one of the finest, best-run resort hotels in the country, though it's far less formal and a great deal friendlier than others in the pantheon. The physical plant is huge, so much so that it has its own post office. There's a choice of nine restaurants, five bars, four swimming pools, and two golf courses (one on the property—the oldest in Florida—and another about twenty minutes away, at a residential community-cum-country club called Breakers West). Tennis lessons, anyone? There are two pros. Facials, massages, and other treatments can be booked at the 20,000-square-foot oceanfront spa. Guests can try paddleboarding, surfing, yoga, or Pilates. If all of the above can't keep a person occupied, there are ten boutiques (including Ralph Lauren, Lilly Pulitzer, Guerlain, a fun jewelry shop called Mix, and Coconut Crew, a children's store) to enjoy. And if that's still not enough, there's all of Palm Beach, just five minutes away by car.

Finally, to the consternation of guests who liked things the way they were, The Breakers has become a desired location for upscale companies to hold their conferences, for charity events, weddings (a huge and growing business), and anniversary celebrations. The resort has had to expand its offerings in order to survive as a year-round complex and to keep its staff (it's the largest employer in Palm Beach). Because the hotel is so enormous, a conference can be held in the South Loggia and a wedding can take place in the North Loggia without disturbing the guests who come there on vacation. In other words, The Breakers in the twenty-first century strives to be almost all things to some people—for a price, naturally. Even today, to walk into the hotel's lobby is to enter an immense and stately space, illuminated by Venetian chandeliers, with a sense of grandeur that is unparalleled.

In 1996, the hotel marked its one-hundredth anniversary, and in 2011, Palm Beach celebrated its centennial. Much has happened in Palm Beach since the arrival of Henry Morrison Flagler—some of it cataclysmic, some of it scandalous, and some of it mildly amusing. Meanwhile, on South County Road, beckoning like the Emerald City is a glorious hotel without equal. As Marylou Whitney, one of the grandest of the surviving grande dames, once declared: "The Breakers is the way you *always* want Palm Beach to be."

Following pages: Stunning aerial view of the grounds at The Breakers hotel.

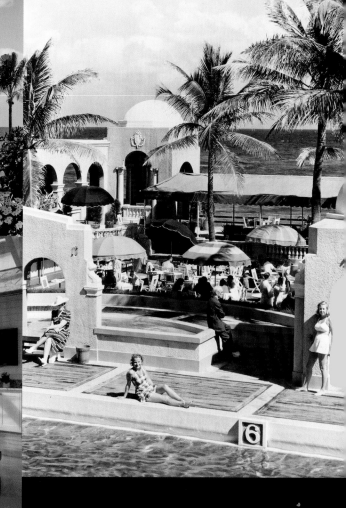

Clockwise from top left: The active pool at The Breakers features a beautiful view of the Atlantic Ocean; vintage photograph of the Breakers pool area; members of the Hearst family on a Breakers beach, 1924; the in-house Lilly Pulitzer boutique offers wares from Palm Beach's most famous fashion designer; beach-goer Betty Pringle being measured up by a policeman, circa 1935; the hotel's immaculate golf course; lounge chairs for poolside relaxing.

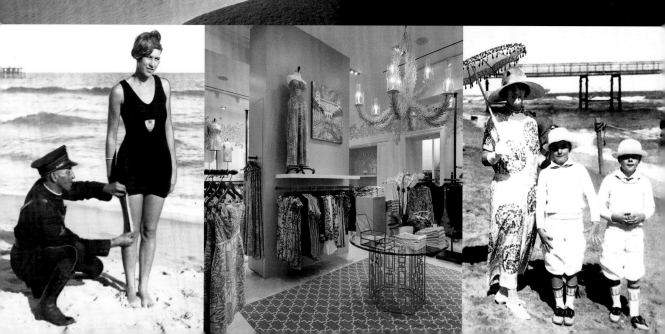

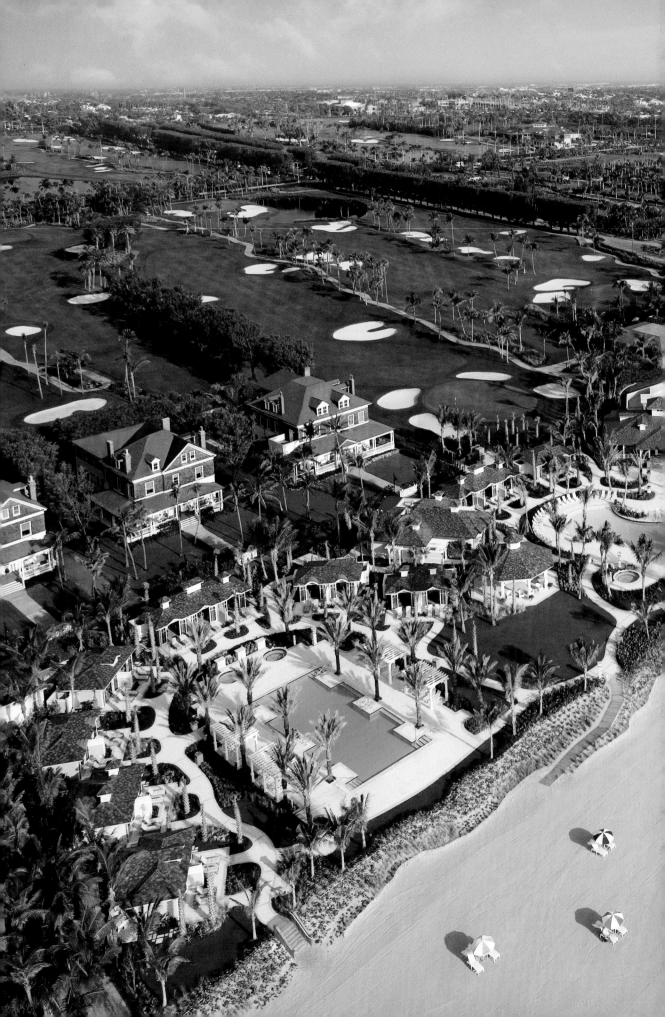

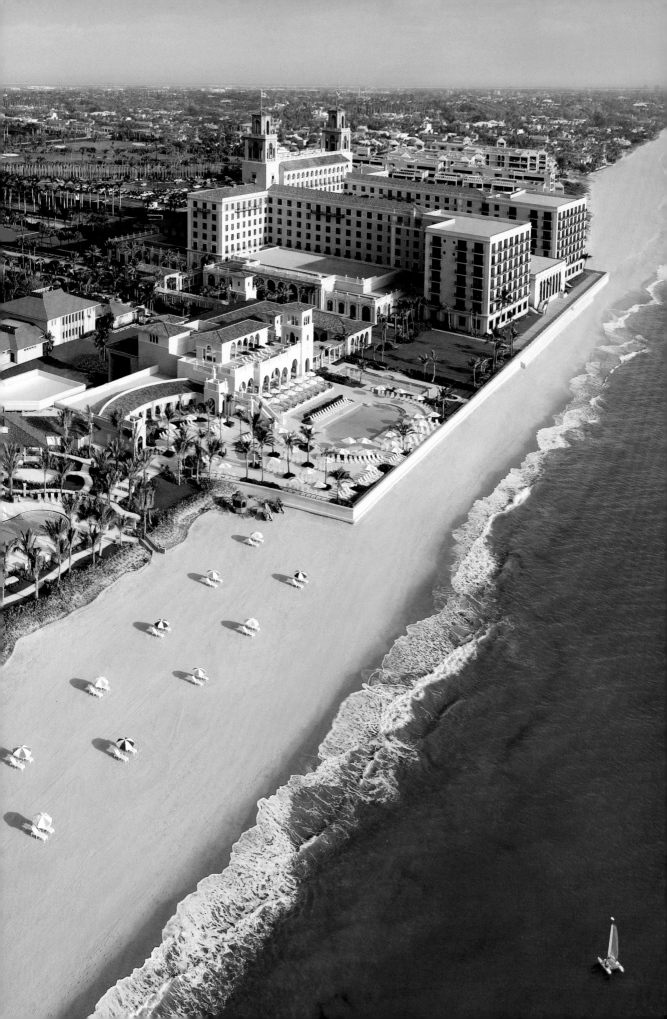

The Master Builders

If it was Flagler who mixed the dough and made the cake of Palm Beach, it was left to two other men, Paris Singer and Addison Mizner, to put the icing on it.

W. A. Powers, *Town & Country,* February 1962

If there is one name to remember when it comes to Palm Beach architects, it is Addison Mizner. His Mediterranean Revival style—terra-cotta roofs, stucco facades, sweeping staircases, dark interiors (to keep things cool in non-air-conditioned times), loggias, courtyards, and verandas—has become synonymous with the city. Mention the "Palm Beach look" and Mizner immediately leaps to mind. Born in California in 1872, the son of a U.S. envoy to Guatemala and other Central American countries, Mizner was a world traveler who was influenced by much of the architecture he saw on his journeys, in particular Guatemala's Spanish Colonial architecture.

Before Mizner arrived in Palm Beach in 1918—he came for health reasons, invited by his friend Paris Singer, heir to the sewing-machine fortune—most of the homes owned by the rich were Victorian shingle-

Built in 1925, the town hall features Spanish Revival architecture. *Following pages:* Socialite Kimberly Farkas in the courtyard of her Palm Beach home, circa 1982.

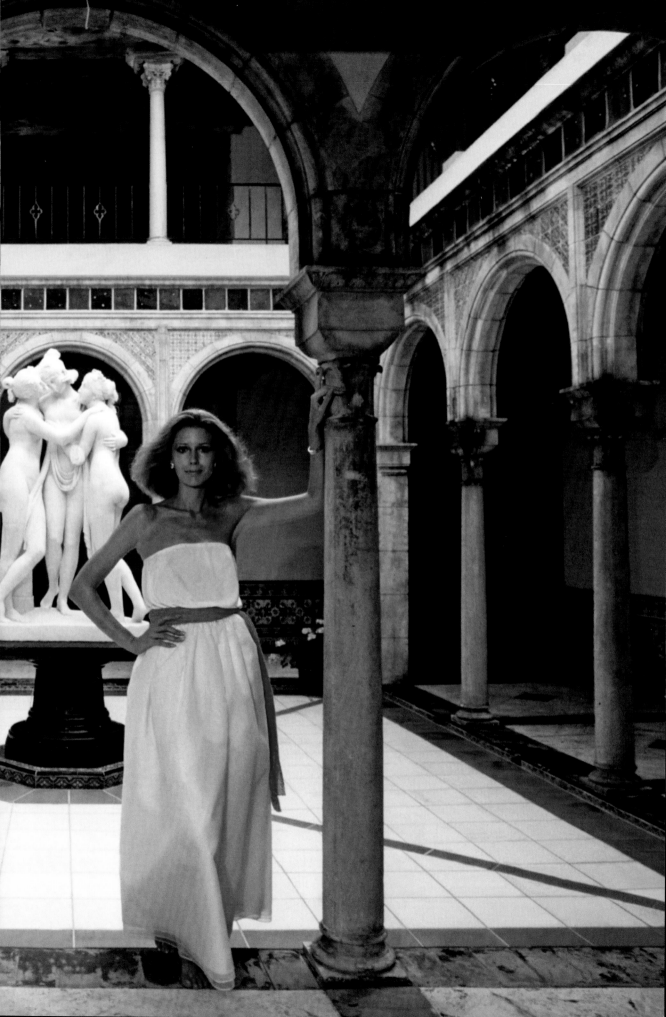

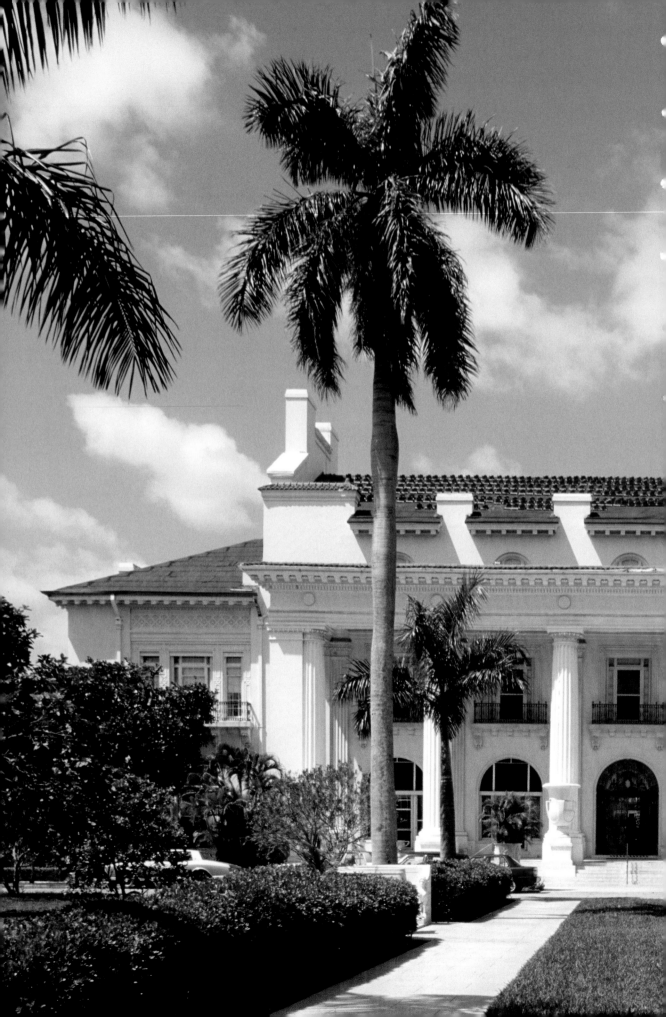

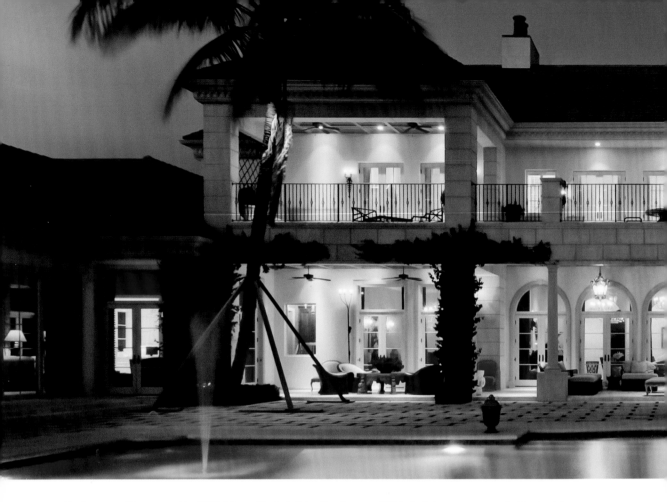

Previous pages: Constructed in 1902, Henry Flagler's Palm Beach estate, Whitehall, is now open as the Flagler Museum.

style "cottages" made of wood. Mizner's materials of choice were stone, tile, and stucco—far better suited to the climate and resistant to, if not totally protected from, hurricanes. He also understood the importance of cross ventilation, keeping the kitchen far from the living areas, and fashioning breezeways to allow air to circulate.

Mizner didn't build houses; rather, he created vast and sprawling villas. Of the nearly two dozen homes that were commissioned in the 1920s and '30s, only a handful survive today. There are, however, many replicas, just as there are imitations. Think about the Stanford White houses in New York and in resort areas like Southampton; faux Richard Neutras in Los Angeles and Palm Springs; and Frank Lloyd Wright copies in many parts of the country. The modus operandi in architecture has always been "If it's worth creating, it's worth re-creating."

At more than six feet tall and two hundred fifty pounds, Mizner was a huge presence in every way. He was widely regarded as a bon vivant, and he quickly became society's darling, invited to every dinner, cocktail party, and outing. And, as often happens, those who hosted him became his clients.

Mizner's first major commission, in 1918, was the Everglades Club at 4 Via Parigi, just off Worth Avenue. Built as a convalescent retreat for wounded World War I troops, it later became

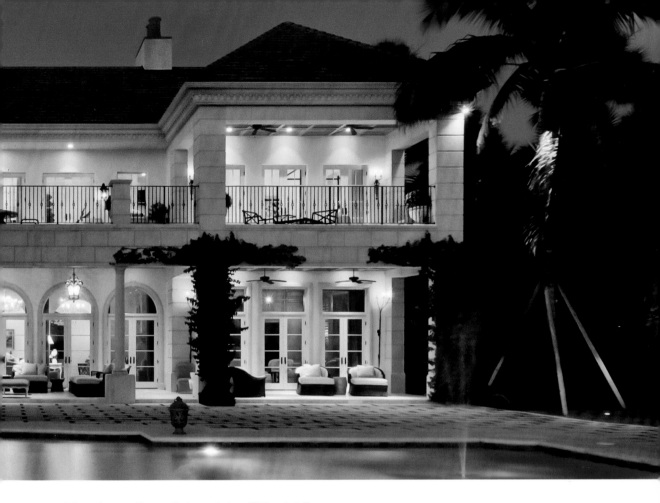

View of a magnificent villa located along Billionaire's Row.

a private club. It remains the most exclusive—in every sense of the word—club in Palm Beach. No debutante could have had a more fitting introduction to society than at the Everglades Club.

Prominent families such as the Stotesburys, Wanamakers, Vanderbilts, Phippses, Warburtons, and Biddles had the architect design houses for them, with names like Villa des Cygnes ("house of the swans"), El Mirasol, Villa Flora, Amado, Casa Nana, and El Solano. Mizner originally built El Solano for himself but sold it to Harold Vanderbilt (years later it was bought by John Lennon). El Solano, at 720 South Ocean Boulevard, still stands. He also developed two of the prettiest shopping areas off Worth Avenue—Via Mizner and Via Parigi—which exist to this day.

Mizner's ambitions didn't stop at Palm Beach. He ventured south and built what was his most far-reaching project, a resort in Boca Raton, which drove him into bankruptcy. He also formed the Mizner Development Corporation with wealthy investor-friends like Paris Singer, Elizabeth Arden, members of the Vanderbilt family, and Irving Berlin. That, too, ended badly. Mizner might have been a gifted architect but as a developer he was no Henry Morrison Flagler.

Nevertheless, Mizner's mark on Palm Beach was indelible. Stephen Sondheim even wrote a musical, *Road Show,* based on the picaresque lives of Addison and his wily brother, Wilson, who

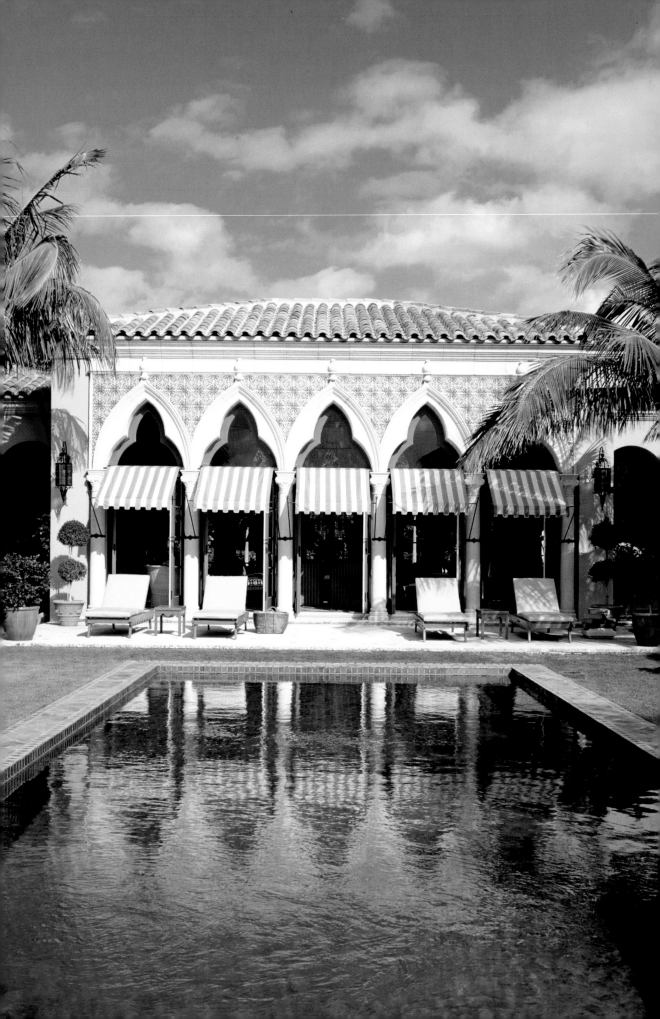

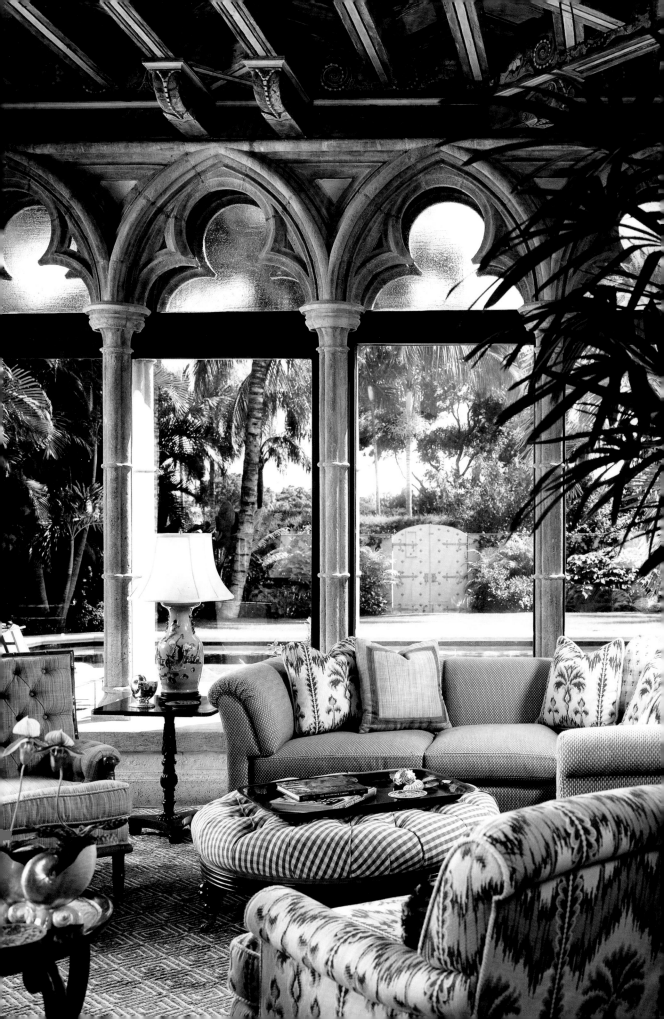

were known for their exploits and misadventures. But it was Addison who became the legend, thanks in large part to his storied buildings in Palm Beach.

Addison Mizner may have been Palm Beach's first and most famous architect, but others followed close on his heels: Marion Sims Wyeth, Maurice Fatio, Joseph Urban, and John L. Volk. Several of these men added to or improved upon Mizner's work. Wyeth, a New York architect, designed the exterior of Marjorie Merriweather Post's Mar-a-Lago (Urban designed the interior), as well as the Norton Museum of Art in West Palm Beach.

Born in Vienna, Urban had strong roots in the theater before he turned to architectural design; he'd created sets for the Ziegfeld Follies, the Boston Opera Company, and New York's Metropolitan Opera. One of his most important clients was William Randolph Hearst, who commissioned Urban to design the original Hearst building on West 57th Street in Manhattan, today a landmark and part of the Hearst Tower. Its original facade, splendidly restored, is the base of Norman Foster's soaring Hearst Tower. The auditorium within is appropriately called the Joseph Urban Theater, in tribute.

In the 1920s, Urban was brought on board to design Mar-a-Lago because Mrs. Post liked his theatrical style. Now owned by Donald Trump, Mar-a-Lago—Spanish for "sea to lake"—is set on twenty acres and, as its name suggests, stretches from the Atlantic Ocean to Lake Worth. Everything in it came from somewhere in Europe: The frescoes are from Florence, the ceilings from Venice, the tiles from Spain; and the dining room is a replica of Rome's Palazzo Chigi. In sum, Mar-a-Lago is more fit for a Medici than a Post. Trump bought it in 1985 and turned it into a private club in 1995. It is practically next door to the Bath and Tennis Club. The two structures, both designed by Urban, couldn't be more different demographically.

Swiss-born Maurice Fatio relocated from New York—where he had a thriving business—to Palm Beach in 1925. Like Mizner, he was conversant with the Mediterranean Revival style (Eastover, his house for Harold Vanderbilt in nearby Manalapan, out-Miznered Mizner), but he was also eager to expand his portfolio, incorporating British Colonial, Georgian, and contemporary styles into his work. Fatio was so well-known that Cole Porter wrote this line in one of his songs, "I want to live on Maurice Fatio's patio."

John L. Volk, also born in Austria, brought another architectural vision to Palm Beach, one that was more stately and more reserved. Like those of Mizner, Wyeth, and Fatio, Volk's client list was filled with boldfaced names, including Dodge, Ford, DuPont, and Pulitzer, to name a few. Two of the architect's grandest achievements were Windsong, a magnificent 1939 Georgian Revival home on El Vedado Road, and 1936's White Gables, on South County Road, the first Bermuda-style house constructed in Palm Beach. Aside from his impressive residential properties,

Cover of a 2005 issue of *Town & Country Travel*. *Previous pages*: Architect Jeffrey Smith's Villa Venezia, constructed as a luxury retreat for Damon and Liz Mezzacappa; interior crafted by Scott Snyder, one of Palm Beach's foremost figures in interior design and architecture.

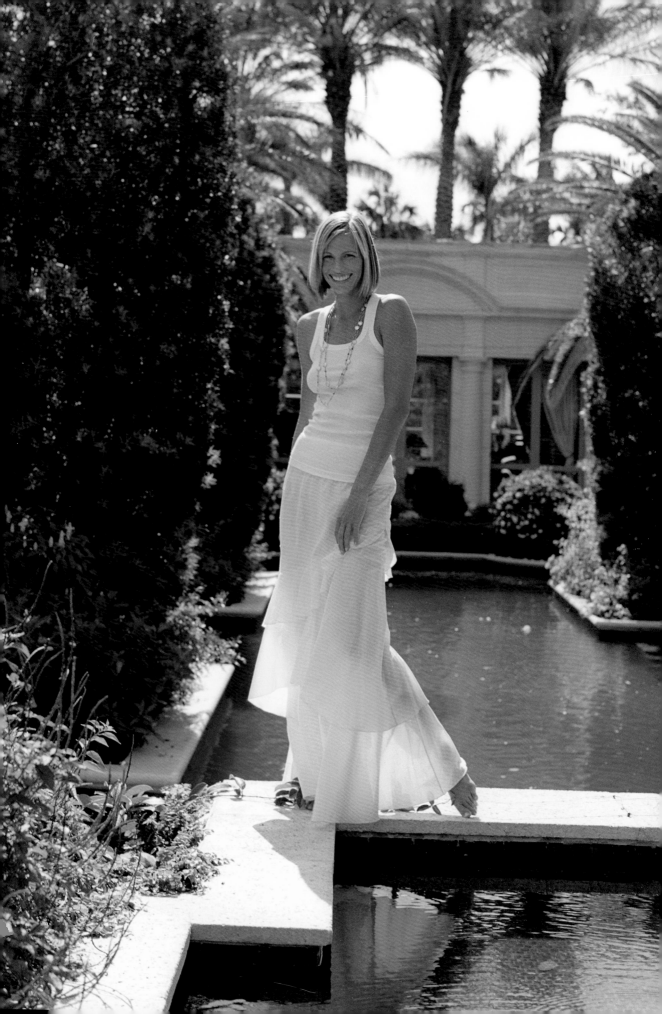

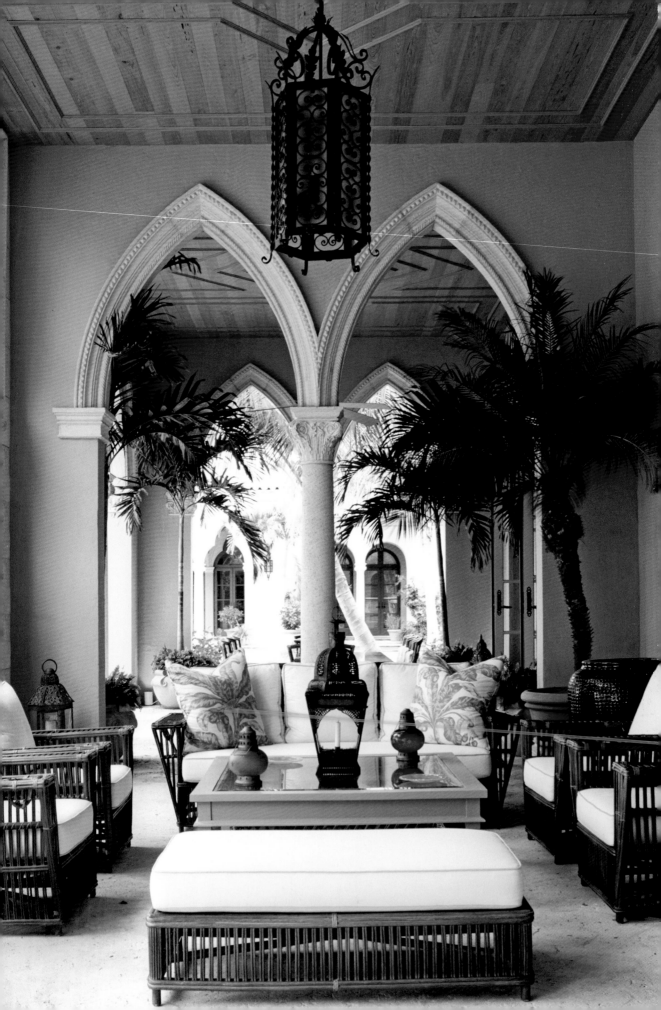

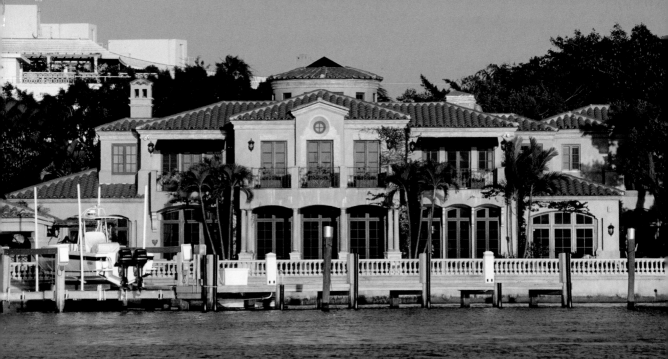

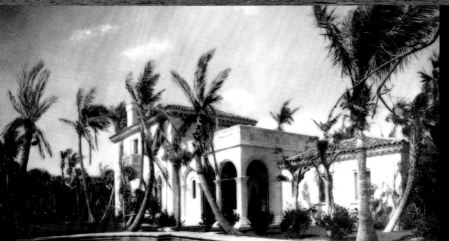

Clockwise from top: Waterfront home by Addison Mizner in Palm Beach; the stately Royal Palm Way is lined with the town's namesake tree; courtly garden at Broadway producer Terry Allen Kramer's villa; historical photograph of the original pool at Casa della Porta, a Maurice Fatio–designed home. *Opposite:* Outdoor seating area at Villa Venezia.

" Mrs. Lauder, who often has two formal dinner parties a week during the height of the season, prefers eighteen at her table. 'I think that number makes a party. It breaks into congenial groups before and after dinner. Then I think it's fun to have a three-piece orchestra for dancing on the patio after coffee and brandy. Everyone likes to dance in Palm Beach, especially the ladies.' "

MONICA MEENAN
TOWN & COUNTRY, MARCH 1974

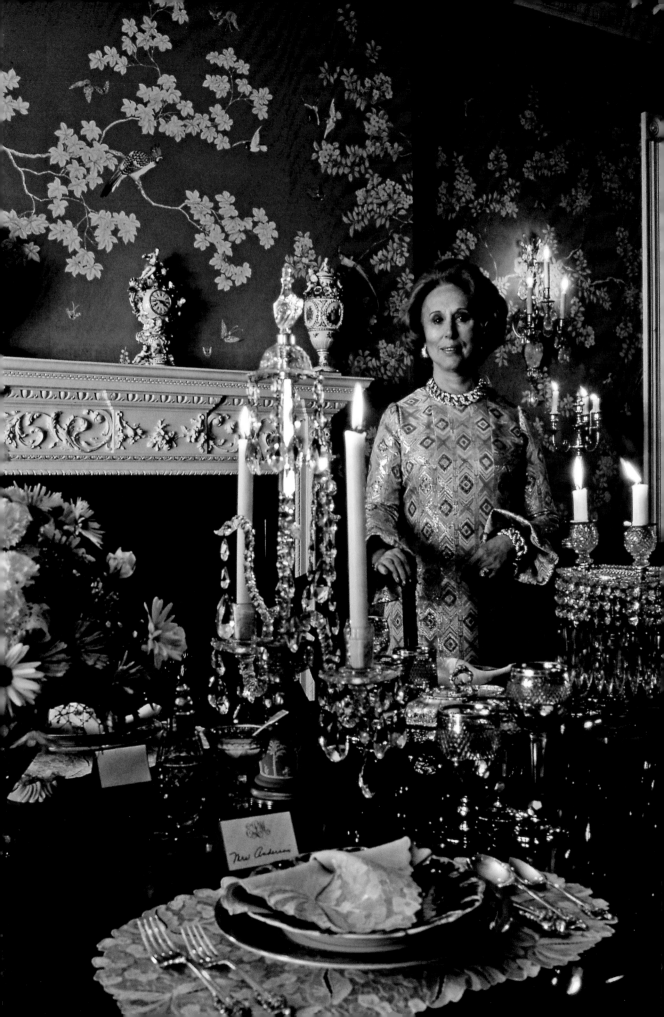

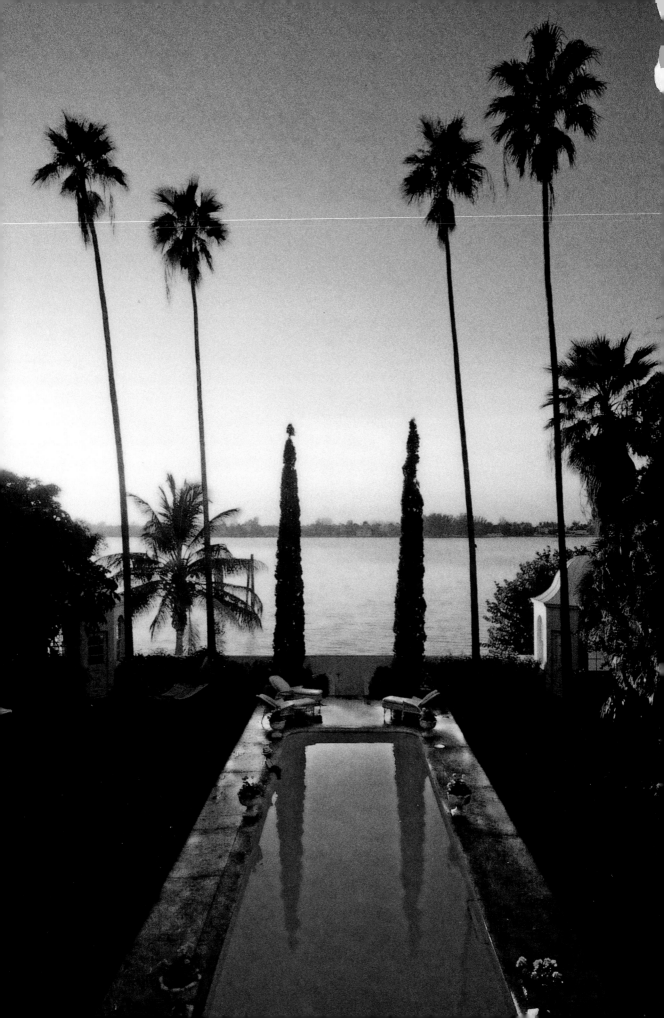

Volk also designed commercial and public buildings for the town of Palm Beach. Palm Beach Town Hall, Poinciana Plaza and Playhouse, Good Samaritan Hospital, additions to the Bath and Tennis Club (which many architects had a hand in), and a good deal of the structures on Worth Avenue were all Volk projects.

Today's Palm Beach still retains the patrician style of its earliest architect, but just as tastes and manner of living change, so does architecture. One of the city's most revered designers is Jeffrey Smith, who has built many of the most graceful residences on the island. Smith often works with interior designer Scott Snyder, another favorite among the wealthy clientele in Palm Beach. But as good as the local talent is, some people prefer to work with outside—and outside-the-box—architects, such as Richard Meier, who is known for his clean, modernist lines, and Peter Marino, whose A-list clients span the globe.

At the same time, designs that are considered too extreme, as well as certain proposed renovations or teardowns, must be submitted to the board of the Preservation Foundation of Palm Beach for approval. Most of the time, the board's strictures prevail. Every so often, the new owner of a beloved but deteriorated house wants it demolished—inviting controversy and spirited debate.

There's hardly a street in Palm Beach proper that doesn't have "important" architecture, whether it be residential or commercial. To glimpse the best of it, drive along South Ocean Boulevard (and the side streets), South and North County roads, and Worth Avenue. You'll see how the 1 percent lives. In a word: superbly. It's no wonder the stretch of South Ocean Boulevard from Southern Boulevard to Sloan's Curve is called Billionaires Row.

Elongated pool at the Vicarage, a home built in 1897 on Lake Trail. *Previous pages:* Cosmetics queen Estée Lauder photographed in her sumptuous Palm Beach dining room, *Town & Country* magazine, March 1974. *Following pages:* Albin and Margo Lykes Holder with friends outside their John Volk–designed poolhouse, 1985.

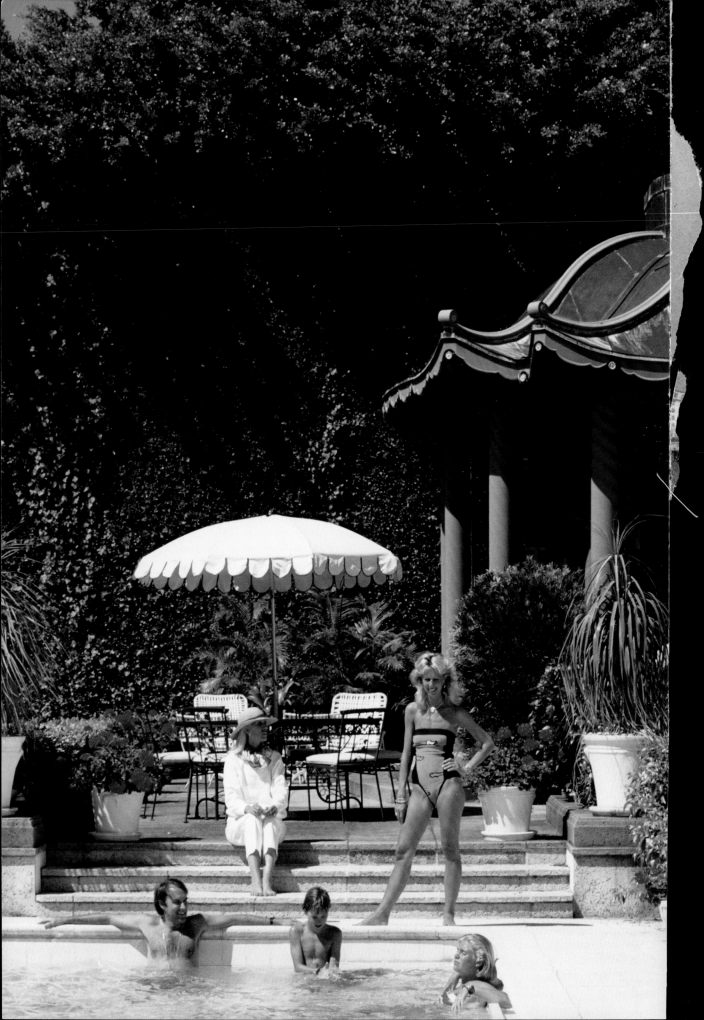

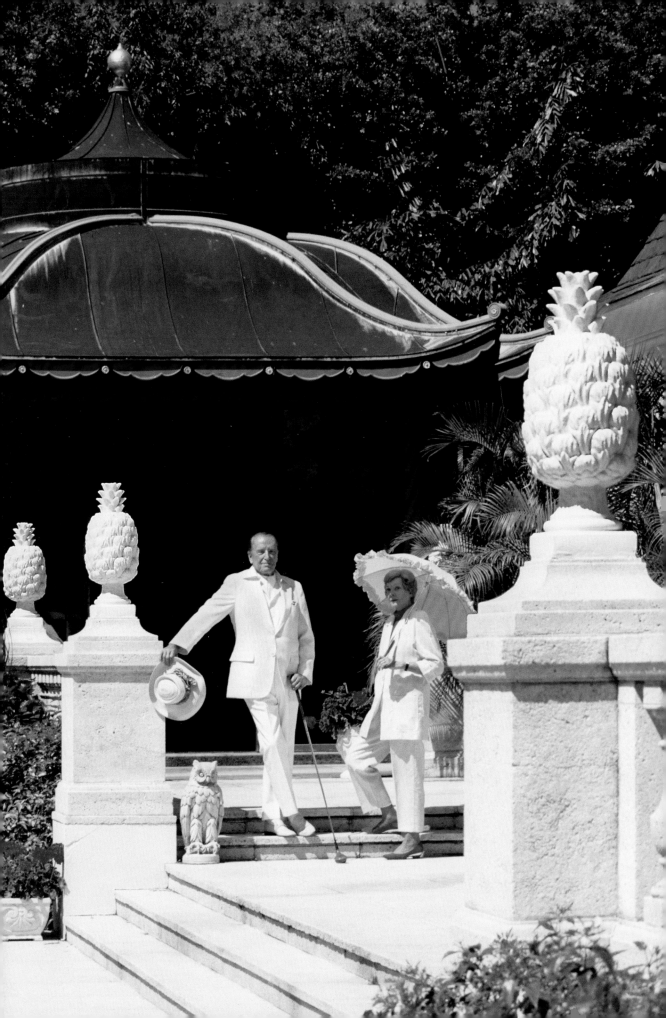

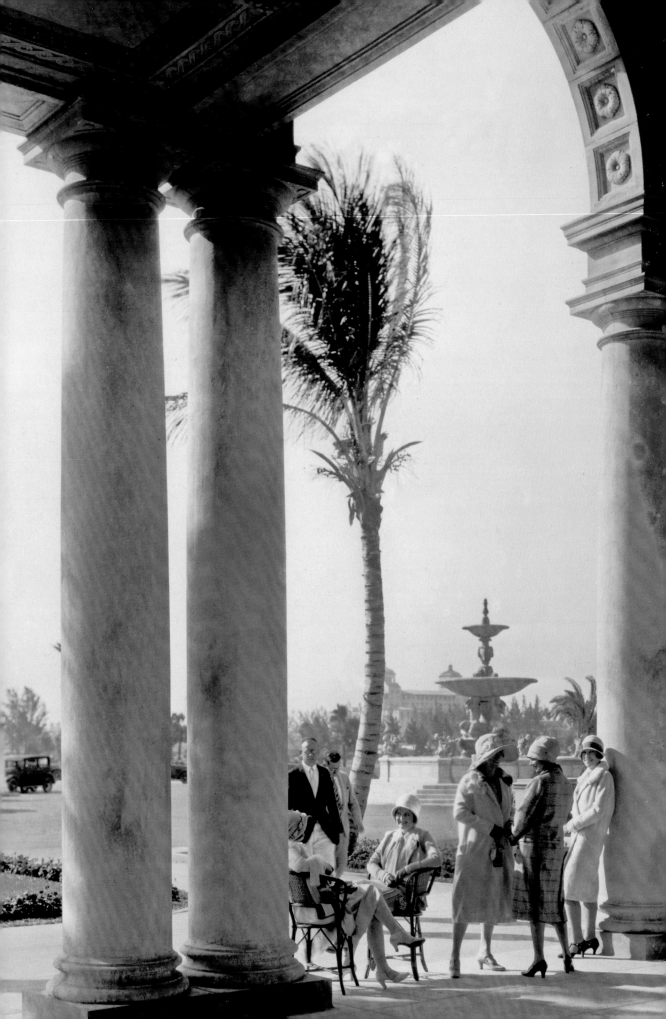

From the Roaring Twenties
to the Subdued Nineties

Palm Beach has lost its zipperoo.

Joseph Kennedy upon hearing that E. R. Bradley's Beach Club casino closed, 1945

The building boom in Palm Beach and elsewhere in south Florida crescendoed in the 1920s, and, as booms go, it was loud, boisterous, and tons of fun. Jay Gatsby would have loved it. The Jazz Age was in full swing under the sun and during many a full moon—perfect for mischief-making. Despite Prohibition, Palm Beach had going for it what it had always had: access. That is to say, no one went thirsty. Somehow, parts of Florida got around the law. In 1926, The Breakers reopened in its modern form, and other hotels and private houses were added to the landscape. In season, there was no better place in America than Palm Beach for the rich to revel. And, boy, did they ever.

The boom was not to last, unfortunately. Two September hurricanes, one in 1926 and another in 1928, caused widespread devastation to the area. The stock market crash in 1929 put a deep dent in Palm Beach, although to read contemporary issues of *Palm Beach Life,* you would never know that anything was amiss. The social set's comings and goings continued to be news. For the privileged few—that is, those who were mostly unaffected by the crash, and the Great Depression that followed—life went on, if not entirely, as usual. Land development, however, slowed to nearly a halt in the 1930s on all parts of the Atlantic Coast.

Japan's attack on Pearl Harbor, on December 7, 1941, and America's subsequent involvement in World War II affected both Palm Beach and her sister city of Boca Raton. In 1942, German and Italian submarines sank a dozen ships off Florida's southeast coast. During the war, The Breakers became a military hospital, and the Boca Raton Resort & Club was turned into a barracks for the U.S. Army, housing soldiers at the nearby Boca Raton Army Air Field base (Army brass called it "the most elegant barracks in history"). *Palm Beach Life* magazine featured photos of visiting Army, Navy, and Marine officers on its social pages. In-season revelry continued but far less flamboyantly. After the war ended in 1945, Palm Beach once again geared up as a jet-setter's paradise.

Since 1926 guests at The Breakers have begun their visits under the distinguished arches of its porte cochere. *Following pages:* Vintage wooden powerboats tied to a dock at Lake Worth, 1930. *Pages 60–61:* Cars parked on Worth Avenue, circa 1953.

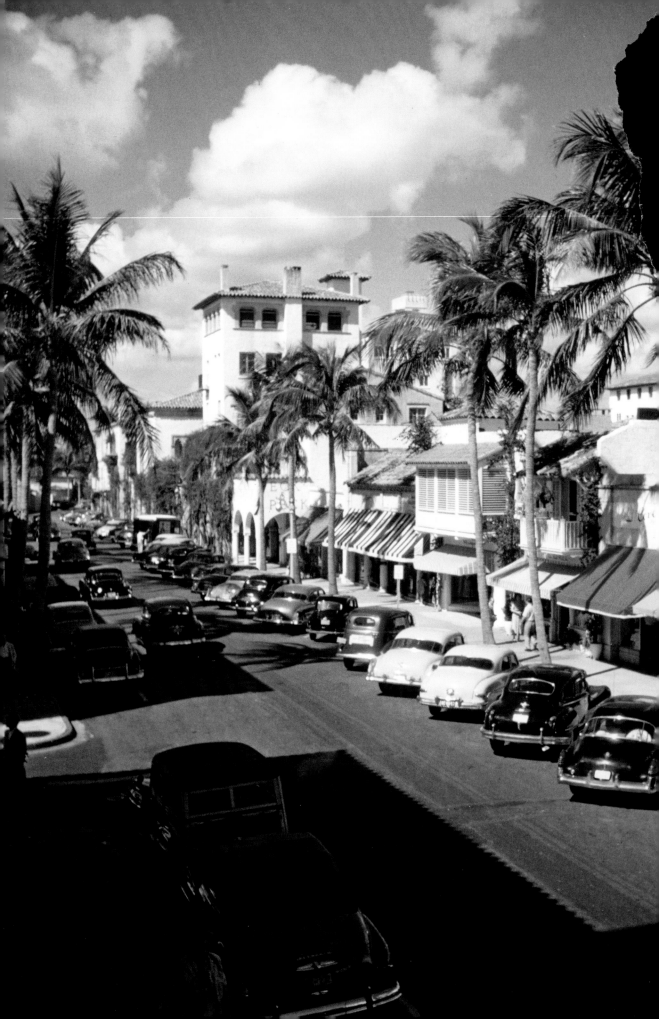

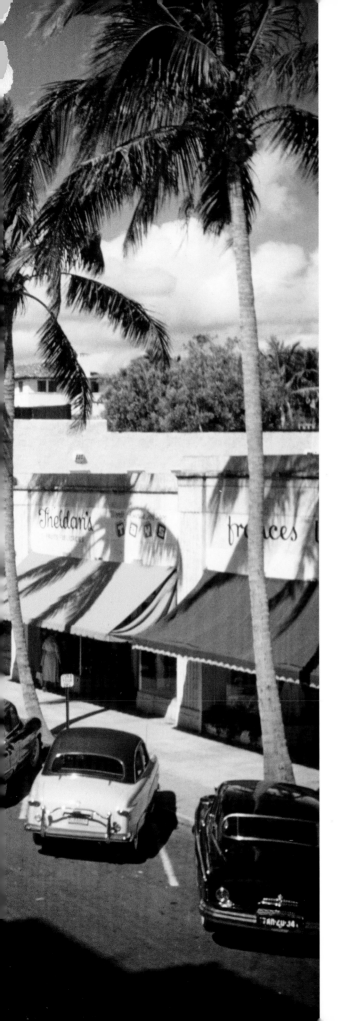

The 1950s ushered in a postwar period of prosperity and rise in the middle class in America, both of which were especially felt in Florida, where the population grew exponentially. By this time, Palm Beach was firmly established as *the* playground for the rich, with no real competition. If you had plenty of money, liked socializing, and wanted a warm and civilized place during the winter, your destination of choice was Palm Beach. Of course, the wealthy also traveled offshore in winter to Havana, though the Cuban haven was off-limits after the revolution there in 1959.

The 1960s began on a vigorous note with the election of Senator John F. Kennedy from Massachusetts as the thirty-fifth president of the United States. At forty-three, the youngest U.S. president ever elected, JFK, along with First Lady Jacqueline Bouvier Kennedy, brought glamour not only to the White House but also to Palm Beach. Rose and Joe Kennedy, the president's parents, had purchased an Addison Mizner house on North Ocean Boulevard in 1933, and during the Camelot years, it became known as the Winter White House. As a senator, Kennedy wrote parts of the Pulitzer prize–winning biography *Profiles in Courage* there, in 1954 and 1955, while recovering from back surgery; he also crafted much of his inaugural address at the Palm Beach compound, in January 1961.

The Kennedy years ended abruptly on November 22, 1963, with the assassination of

Following pages: Mr. and Mrs. George Vanderbilt on New Year's Eve, 1940; tribute to photographer Bert Morgan from the March 1974 issue of *Town & Country.*

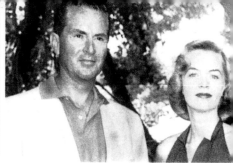

Doris Duke and
Stephen Sanford. 1952

Cecil Smith and Mrs. Ben
Gage at the Polo Ball. 1953

Mrs. Alex D.
Thomson. 1953

Mr. and Mrs. Guilford Dudley at
the Brazilian Court Hotel. 1954

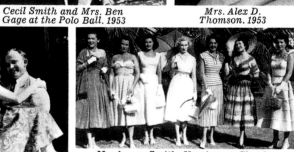

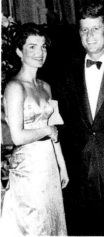

Mrs. Joseph P.
Kennedy. 1954

Mesdames Smith, Heminway, Sheedy,
Sweeny, Topping, Sanford, Douglas, Jr. 1955

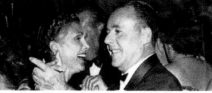
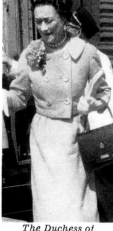

Mrs. Edith G.H.
Bliss. 1954

Charles Zaniewski carries
Mrs. P. Rubirosa. 1955

Mrs. Edward F. Hutton and Walter T.
Shirley at the Polo Ball. 1956

The Duchess of
Windsor. 1956

Senator and Mrs.
John F. Kennedy. 1957

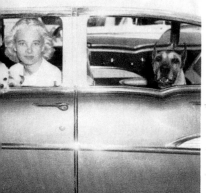

Mrs. Winston Guest on
Worth Avenue. 1957

Mrs. Mary Howes
at the airport. 1957

Mrs. John W. Salisbury
on Worth Avenue. 1957

Mrs. Robert Grace with admiring
canine friend on Worth Avenue. 1957

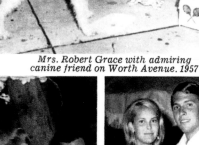
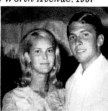

Mrs. Charles
Crocker. 1957

Mrs. Paul
Maddock. 1957

Mollie Babcock and H.
Loy Anderson, Jr. 1965

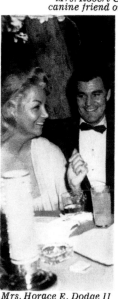

Mrs. Loèl Guinness at
tennis matches. 1957

Mrs. Thomas Shevlin with
daughter, Sherley. 1957

Mrs. Horace E. Dodge II
and Daniel Moran. 1964

Mrs. Victor Farris
and Bob Hope. 1965

66 A man who for three generations pronounced 'to-may-to' 'to-mah-to.' 99

CHARLES A. MUNN,
"MR. PALM BEACH"

DEFINITION OF A PALM BEACH GENTLEMAN IN
CLEVELAND ARMORY'S *THE LAST RESORTS* (1952)

JFK in Dallas; just days earlier, he had spent what was to be his last holiday in Palm Beach. A period of turmoil followed in the 1960s: the Vietnam War and the antiwar movement; the assassinations of the president's brother Robert Kennedy and of civil rights leader Martin Luther King Jr.; race riots; not to mention the decade's new openness regarding sex, drugs, and rock and roll. Private clubs like the Everglades and the Bath and Tennis, as well as entertaining grandly at homes in Palm Beach, came in handy as sources of retreat. On page after page, *Town & Country* magazine pictured women like Mrs. Stephen "Laddie" Sanford and Mrs. Cornelius Vanderbilt (Marylou) Whitney, committee heads of the Flamingo Ball, and other women enjoying the Palm Beach lifestyle. A mid-1960s cover of the magazine featured a photo of the Duke of Windsor and his golf clubs at the Lost Tree Club in North Palm Beach; the duke and duchess were frequent guests in Palm Beach, as those in the wealthy enclave were more than happy to host the controversial couple.

The 1970s reestablished Palm Beach as ground zero for the über rich with more building—as well as rebuilding and expansion—of private houses. The international crowd jetted in from Europe and South America. Those who weren't able to buy houses in Palm Beach proper—and we do mean proper—went south of Sloan's Curve on South Ocean Boulevard, toward and including the town of Manalapan.

Prominent Palm Beacher Charles A. Munn photographed in the February 1962 issue of *Town & Country* magazine.

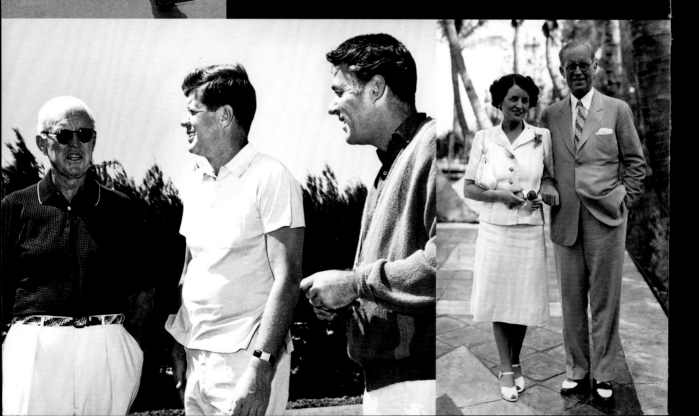

Clockwise from left: Jackie Kennedy after attending Good Friday services, 1961; Rose Kennedy, The Duchess of Windsor, and The Duke of Windsor at the Everglades Club, 1967; Joseph and Rose Kennedy strolling in Palm Beach, 1940; Joseph Kennedy, President John F. Kennedy, and actor Peter Lawford. *Opposite, clockwise from top left:* Peter Lawford and friends on Worth Avenue, 1958; Rose Kennedy on Worth Avenue; JFK with Jacqueline Kennedy, 1961; Kennedy family on the *Honey Fitz,* JFK's presidential yacht; Ted Kennedy doing some last-minute Christmas shopping on Worth Avenue; John F. Kennedy with his father, Joseph Kennedy, on the runway of the West Palm Beach airport, 1961; the Kennedy family outside of their family's Palm Beach estate on Easter Sunday, 1963; Eunice Kennedy, John F. Kennedy's sister, walking on the beach at the Sun and Surf Club, 1940. *Following pages:* On sofa, left to right: Melita Franzheim, Mrs. Whitney Tower Jr., and Barbara Franzheim Dror by the pool at the Franzheim Dror's house in Palm Beach, 1984.

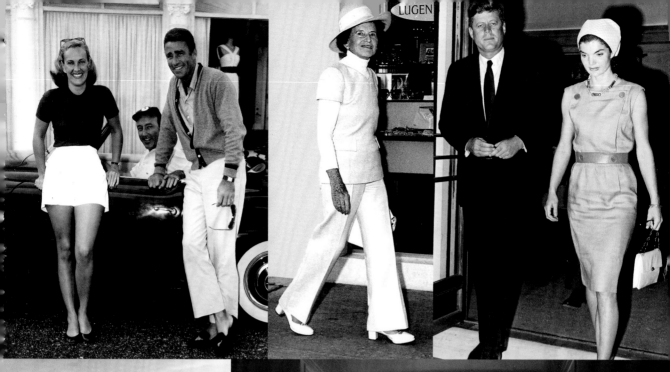

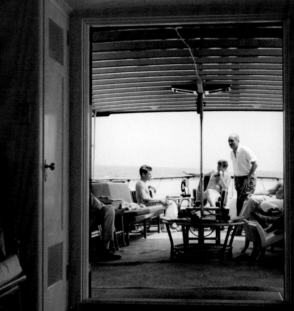

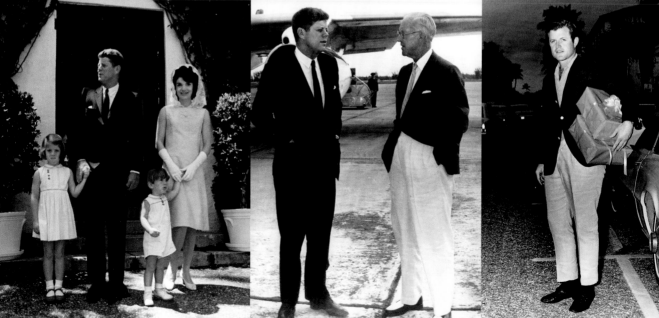

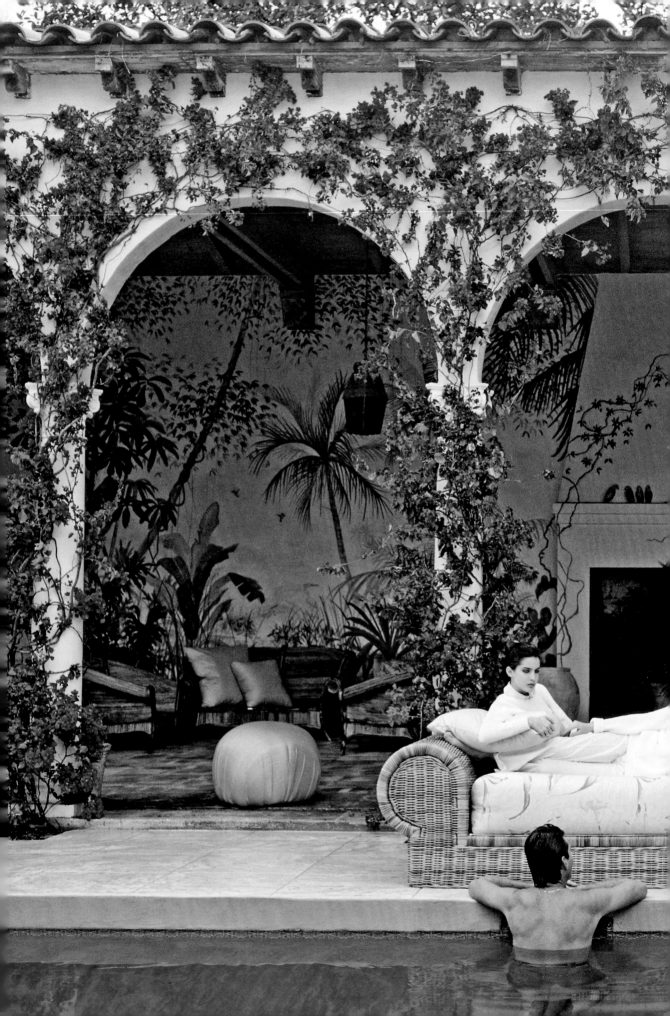

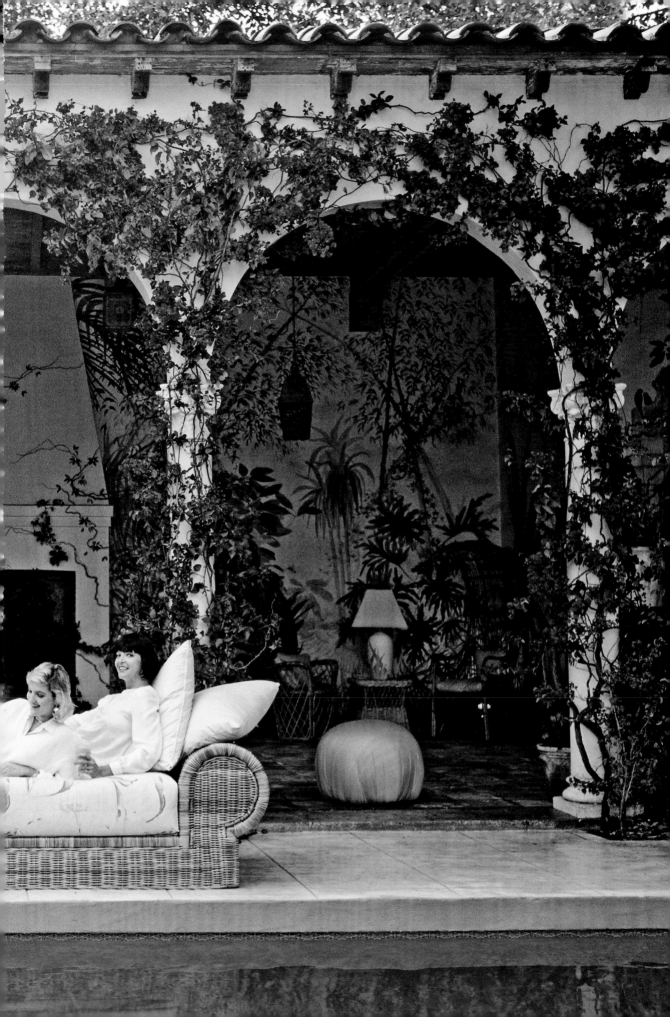

> *Johnny-come-lately, raffish or not, Palm Beach has nevertheless outlasted and outdistanced the majority of Old Guard resorts and today stands, along with Southampton, as the greatest stronghold of what's left of Society in America.*

W. A. POWERS
TOWN & COUNTRY, FEBRUARY, 1962

> *First-time visitors sometimes find it hard to believe that Palm Beach is such a small town, so large is its international reputation as a winter playground of the rich and famous.*

DARRELL HOFHEINZ
EDITOR, PALM BEACH DAILY NEWS

> *There is a saying in Palm Beach that what God didn't create in Palm Beach, the Garden Club did.*

BRIAN SAIPE
EVENT ORGANIZER

" There's an old saw in Palm Beach that goes like this: When you first come to Palm Beach, you think you're the oldest and the richest. Then you realize you're the youngest and the poorest. "

JACKIE WELD DRAKE
PALM BEACH SOCIALITE

" My perfect Palm Beach day is lunch at the beach, a mile swim, and a family night at the movies—with wardrobe changes for everything, of course. "

AMY FINE COLLINS
WRITER AND FREQUENT VISITOR

The 1980s was the Reagan era, and full-haired women ruled Palm Beach. In 1982, newspaper heir Herbert (Peter) Pulitzer Jr. accused his third wife, Roxanne, of drug-related sexual escapades—a scandal that rocked the community. Things calmed down considerably thereafter. The Pulitzer episode aside, these weren't wild years à la 1920s. They were, however, prosperous ones. Worth Avenue was the Fifth Avenue of Florida. Another building boom was under way on the island, as it was in nearby communities. By the end of the decade, upscale shopping centers like the Gardens Mall in Palm Beach Gardens, north of Palm Beach, and gated communities complete with eighteen-hole golf courses had sprung up. Palm Beach County's reach was wide and highly influential, attracting not just old-money WASPs but also new-money sports stars and venture capitalists, some just for weekends, others on a full-time basis. Palm Beach was becoming virtually a year-round destination—except for hurricane season, which peaks in August, September, and early October, when residents either sweat it out, lock down the hatches, or get out of town altogether.

In the early 1990s, another deep economic drop occurred. Being rich fell into disrepute, and political correctness was all the rage, much to the ire of conservative radio personalities such as Rush Limbaugh (who, incidentally, now calls Palm Beach home). It was a time for the wealthy to go undercover once again, and what better place to be private than protective Palm Beach? William Jefferson Clinton, a Democrat, was elected president in 1992. By the end of his second, and last, term, the economy was once again robust, and many put their money on Clinton's vice president, Al Gore, to become the next president. His opponent in the 2000 race was George W. Bush, a son of former president George H. W. Bush. The election was so close that a recounting of votes in Florida was called. After the final tally—and with the U.S. Supreme Court weighing in to decide the matter—Bush was declared president by a narrow margin, and a new era began. Palm Beach was poised for prime time...again.

An aerial view of the exclusive Bath and Tennis club (foreground), next door to Marjorie Merriweather Post's Mar-a-Lago, circa 1995.

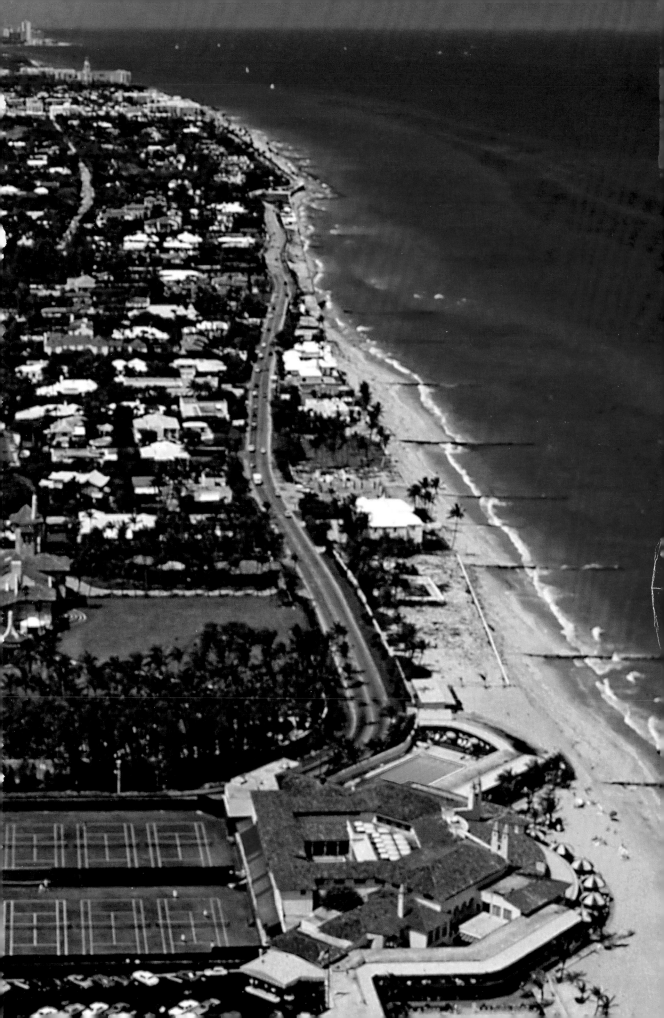

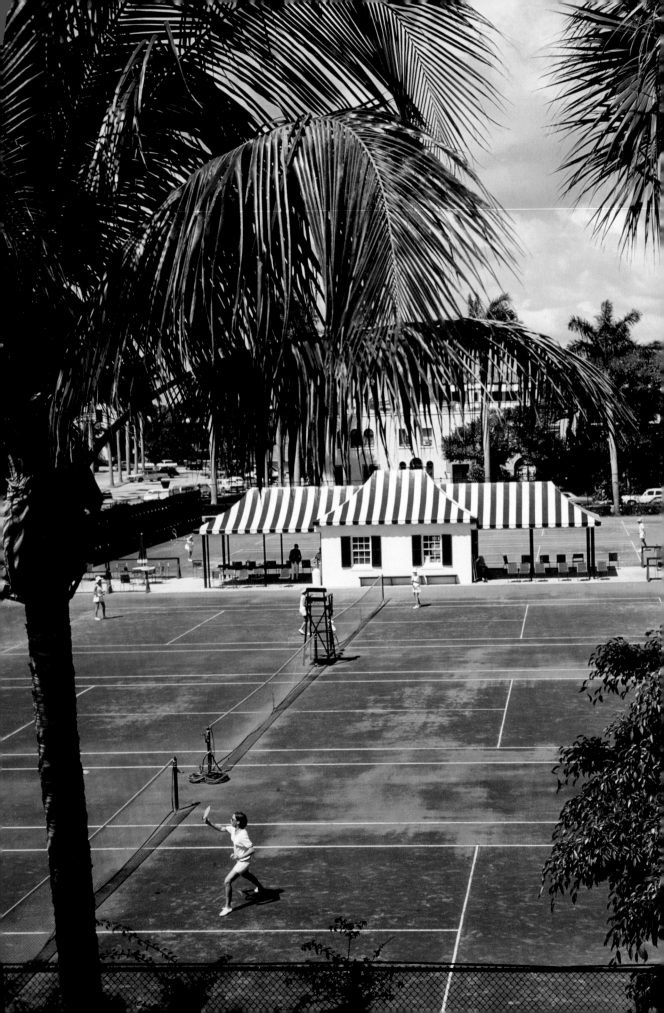

Palm Beach Private, Palm Beach Social

Palm Beach's real Old Guard, however, is made up, as at other social resorts, of a far more powerful group—an autocratic widow matriarchy.

Cleveland Armory, *The Last Resorts,* 1952

What's left of privacy? Ask that question in most places in this country and the usual answer is "not much"—except in Palm Beach. For all its social goings-on, especially during "the Season" (roughly Thanksgiving to Easter), the town enables its residents to keep a low profile behind their high hedges. Police protection is part of it. One of the reasons Palm Beach is so safe is that patrol cars canvass the streets night and day. Another reason is that there are only three bridges—the Southern, the "middle," and the Flagler—that allow access to it. And don't look for signs: There are hardly any. The idea is that if you don't know where you're going, perhaps you shouldn't be heading there.

Tennis courts at Palm Beach's Everglades Club, 1968.
Following pages: Golfers at the Palm Beach Golf Club.

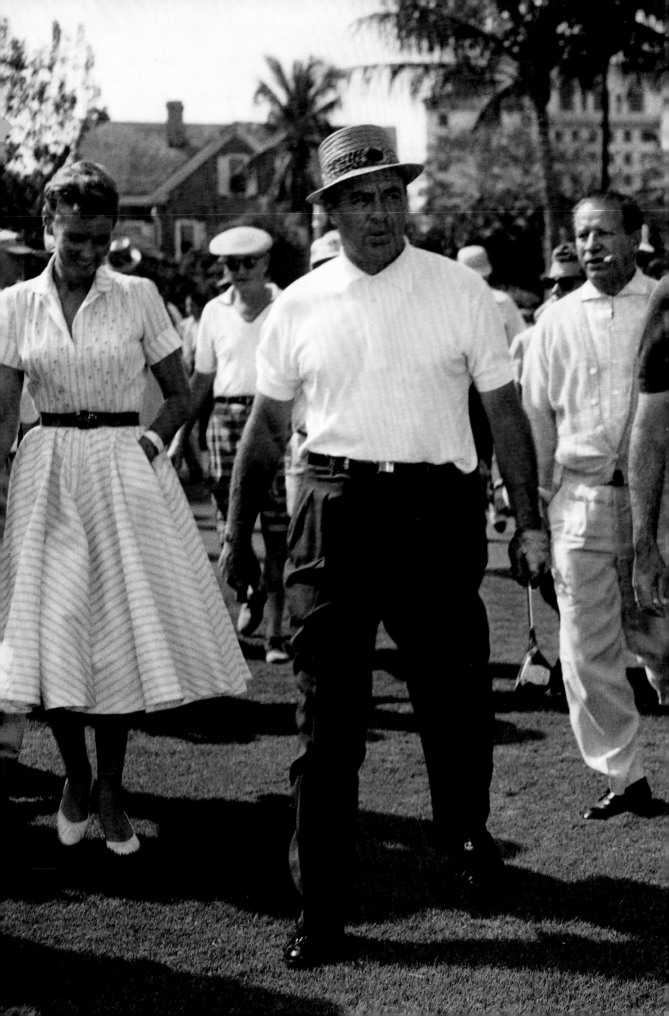

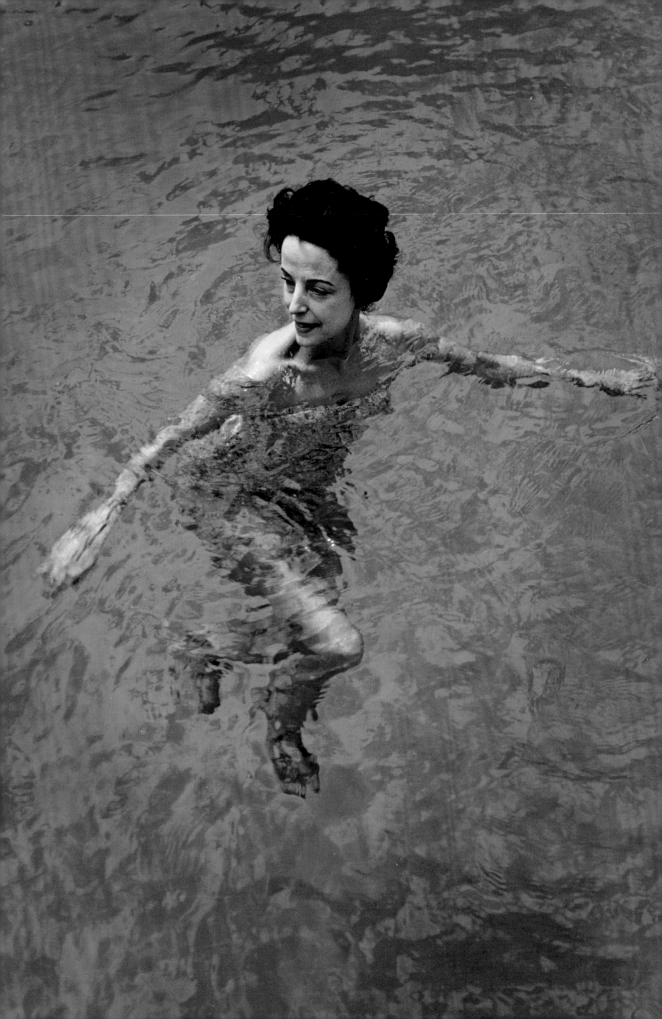

Finally, there's the unwritten rule that is the equivalent of "Keep off the grass" and is more akin to "Don't you dare." What will happen if you trespass? Often you can't, because there are gates. If there isn't a gate, there may be a sign indicating a security system. In other words, mind your own business and go your own way.

Private clubs proliferate in Palm Beach. The two that are hardest to get into are the Everglades and the Bath and Tennis. You must be invited by a member to apply, and even then your chances of admission are slim to none. Other private clubs that are popular but not so particular are the Sailfish Club (great for families and open all year round), the Palm Beach Country Club (to which Bernard Madoff belonged), Club Colette (a popular restaurant and nightclub), Mar-a-Lago (if you can pony up the entry fee), the Breakers Ocean Club (connected to the hotel), the Beach Club, and the Yacht Club. Several golf clubs like the Seminole, Loxahatchee, and the Trump International (built by Donald Trump and affiliated with the Mar-a-Lago Club) are also members-only. And in all cases, you have to be recommended by an existing member to join. This is the way it works with all private clubs everywhere—only more so in Palm Beach. Okay, a lot more so.

Private clubs constitute a significant part of Palm Beach social life: They're where people gather to eat, drink, entertain their friends, play golf and tennis, swim, gossip, and hide from the rest of the world. They come in especially handy during hard economic times—if, that is, you can still afford the annual fees. After the Madoff scandal in 2008, some members of the Palm Beach Country Club were so affected financially that they could no longer belong.

What's so fascinating about Palm Beachers is that many of them claim to cherish their privacy and yet choose to reside in one of the most fiercely social and status-seeking places on the planet. During any week of the season, a couple can be out for lunch and dinner every day and evening. More charity balls and luncheons take place in Palm Beach than anywhere else—mostly at The Breakers and Mar-a-Lago. Consequently, millions of dollars are raised for the Red Cross, the American Cancer Society, the Boys & Girls Clubs, and for local organizations like the Society of the Four Arts, the Kravis Center for the Performing Arts, and the Norton Museum of Art. These activities ensure that event planners like Bruce Sutka and Tom Mathieu are in business, keep tony hair salons such as Frédéric Fekkai booked, and offer a chance for women to shop for a new outfit and men to put on their well-worn tuxedos and have a good old time for a great cause.

Money is raised not only by buying seats and tables but also through live and silent auctions conducted during an event. One of Palm Beach's most effective and affable auctioneers is Tommy Quick, whose father was the Quick of Quick & Reilly, the New York–based brokerage house. "Philanthropy was part of my family's culture, even when we were kids," says Tommy. Eleven

Socialite and fashion icon Gloria Guinness swimming in her Manalapan pool, 1959. *Following pages:* Inger Anderson (far left), wife of banker Harry Loy Anderson, at Mrs. Warrington Gillet's house in Palm Beach, 1982.

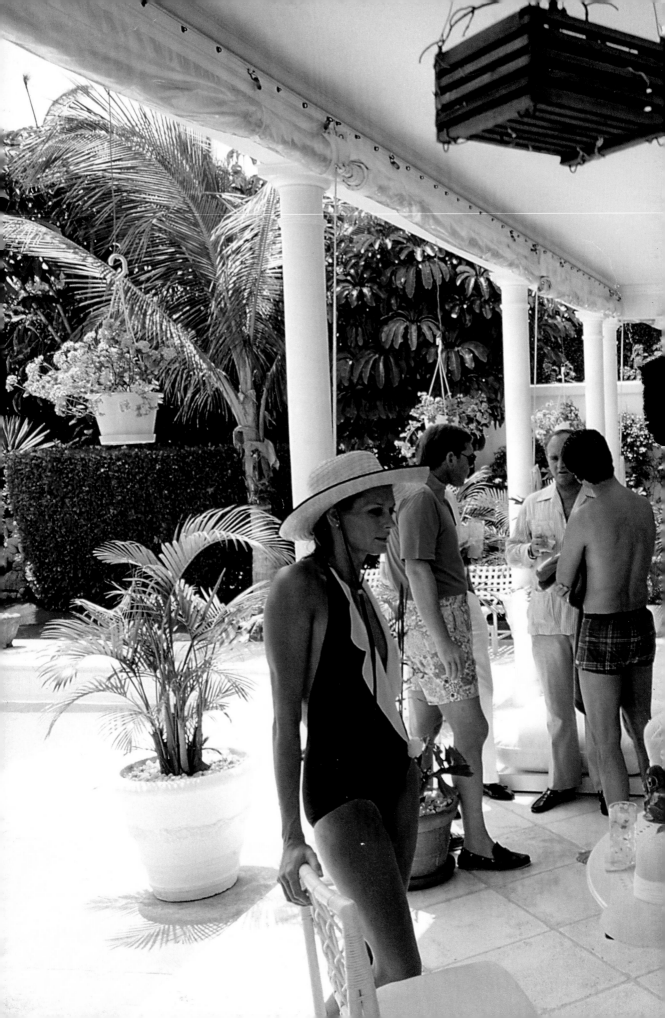

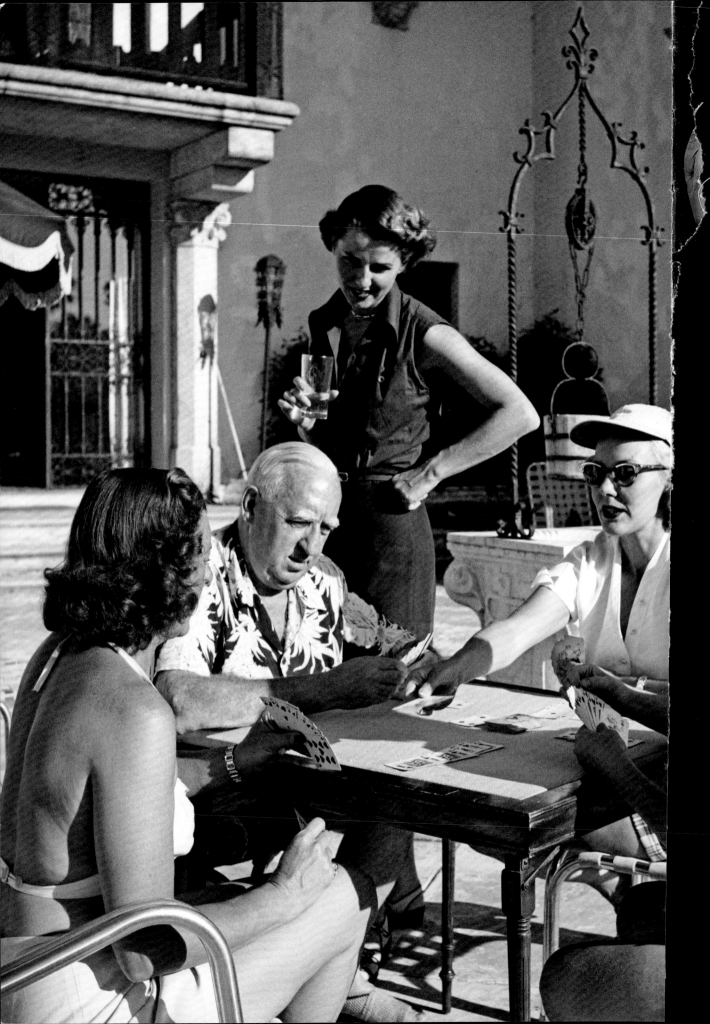

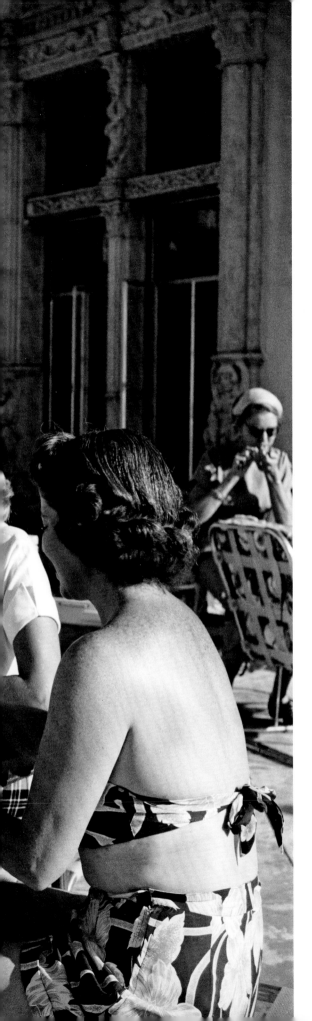

years ago, after his father passed away, he left the family firm, moved to Palm Beach, and began building and selling spec homes in the high-priced community of Lost Tree Village. He then started a foundation that now gives away millions of dollars, a good deal of it to causes in Palm Beach. His auctioneering gig was by accident, but he's taken it on with enthusiasm and success. Tommy may well be the most photographed person on the party pages of the *Palm Beach Daily News,* aka "The Shiny Sheet." One good reason: He knows how to smile for the camera and makes any event seem like it was worth going to.

Palm Beach charity events are also known for cultivating a breed of single men referred to as "walkers"—i.e., gentlemen companions who offer their company for the evening when a woman's spouse is either not available or deceased. Walkers are not exclusive to Palm Beach, but some men there have virtually made a career out of being one. Accompanying an unattached woman— she's usually a friend or acquaintance—is not considered in the least bit untoward, particularly because there are so many wealthy widows who would otherwise spend their evenings alone at home.

Walkers serve a purpose in a town that is highly matriarchal. Even if a woman is not a widow, her spouse simply may not want to attend yet another black-tie function. So Mrs. So-and-So will invite her pal, let's call

From left: Mrs. Benjamin Black, Raymond Schindler, Jerry Rowen, Betty Bosworth, and Mrs. Schindler playing canasta in Palm Beach, circa 1955.

Clockwise from top left: The portico between the marble patio and the main lounge at the private Everglades Club; 1920s Palm Beach society on the marble patio at the Everglades Club; Tommy Quick with Eddy Taylor; Prince Charles with socialite Jorie Butler Kent; Peter and Lilly Pulitzer with furry friends soon after their wedding; Barbara Hutton and Robert Sweeney watching tennis at the Everglades Club, 1940.

Clockwise from top left: The lobby of the Everglades Club; Jack Nicklaus and Bob Hope playing golf at The Breakers; exterior of the Everglades Club; Jean Flagler Matthews, one of Henry Flagler's granddaughters; cell phones aren't allowed at the Everglades Club; the Duke of Windsor on the cover of a 1965 issue of *Town & Country*; actor George Hamilton with Anthony Shriver, 2011; Dominican diplomat and socialite Porfirio Rubirosa riding a horse, 1955. *Following pages:* Jorie Butler Kent with her stepson, Joss Kent, during a polo match at Wellington, 1982.

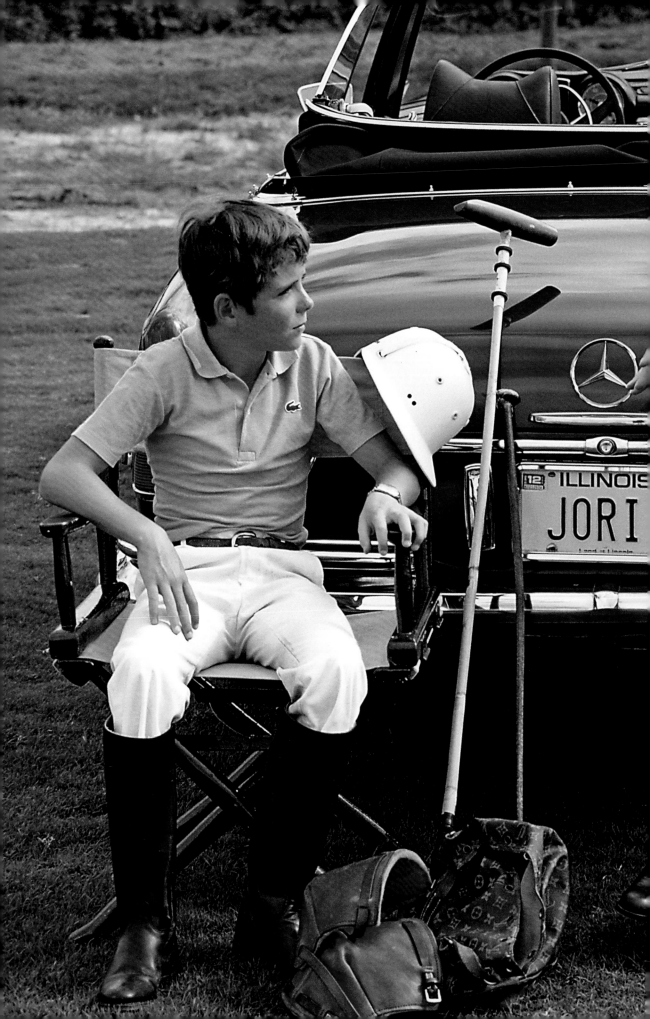

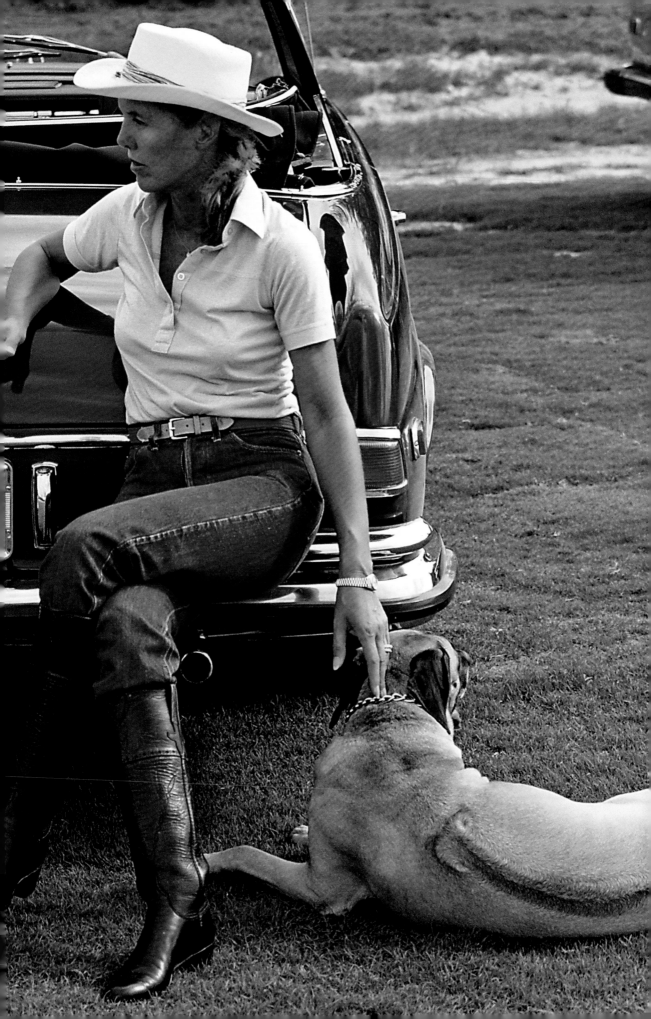

*"Palm Beach 'musts':
No socks. Sweaters over shoulders.
Jewelry... A hairstyle known as
'the Palm Beach crash helmet.'
Luxe cars. Private jets. Yachts.
Bridge. Golf and tennis."*

STEVEN STOLMAN
WRITER AND DESIGNER

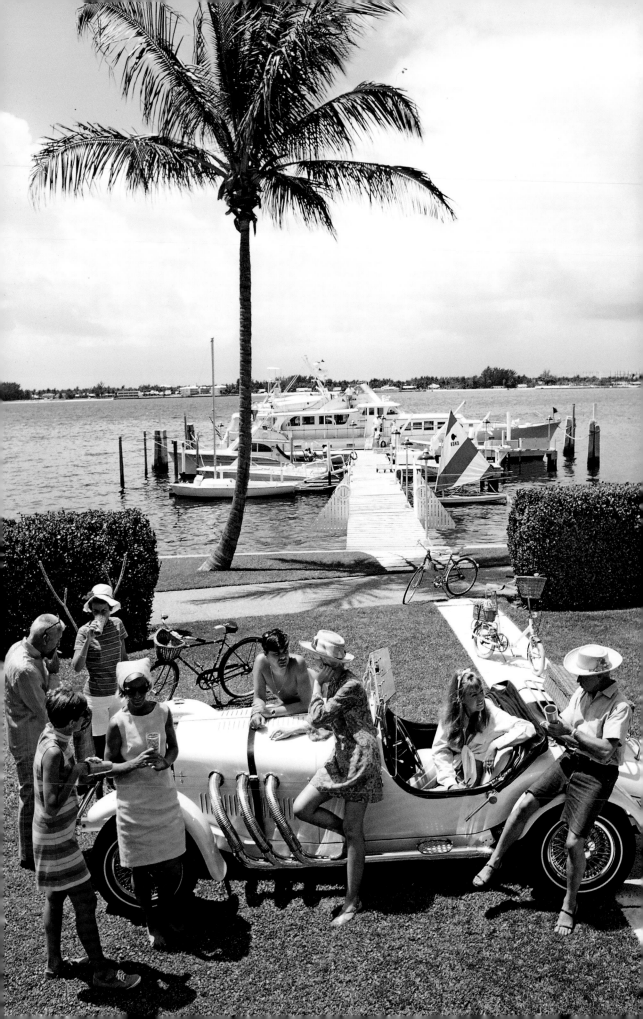

him Todd, in his place and everybody's happy. By the way, there's also a name for such women: They are known as SWORDs ("single, widowed, or divorced"). So ubiquitous is the combination of elderly women and walkers that it prompted social commentator Simon Doonan to describe Palm Beach as "the gay '90s: where all the men are gay and all the women are in their nineties."

While many men have amassed the riches that allow for a life in Palm Beach, it's the women who make the place move. They are the chairs and committee members of charity events, organizers of the social calendar, high-end consumers, entertainers, and culture mavens.

One of them is Emilia Fanjul, wife of the sugar-mill magnate J. Pepe Fanjul. She has a long history in Palm Beach. Everyone there knows who and what the Fanjuls are: an important part of the social and economic landscape. Emilia's memories of the Palm Beach social sphere date back to the late 1960s. "We'd get dressed up every night in black tie and go to people's houses or the Everglades Club," she recalls. "Often we were by far the youngest couple in the room. We'd play croquet at The Breakers." Today, the Fanjuls are considered to be key members of the Palm Beach establishment.

According to Palm Beach native and shoe designer Lily Holt, the people who best understand the social mores are the Old Guard, as in those who have been raised on the island—"My family is five-generation Palm Beachers," she says. Holt recalls a highlight of Palm Beach social life: "One year my mother entertained the queen of Thailand at our house—eight hundred people and a lot of secret service!"

Pauline Pitt, an interior designer, is also a fixture on the Palm Beach social circuit. Descended from two wealthy old-line American families—the Munns and Bakers—who spent winters there, Pitt established herself in Palm Beach after years of being a New Yorker. A social and philanthropic force in the town, she is continuing the matriarchal heritage of Palm Beach society, but without the grande-dame trappings of her predecessors.

One such grande dame was cosmetics queen Estée Lauder. Entirely self-made, she was enormously successful by the time she and her husband, Joseph Lauder, entered Palm Beach society in the 1950s. In 1964, they bought a home designed by Wyeth and King in 1938. Her dinner parties—she considered eighteen the right number of guests—were as legendary as she was. Estée's son, Leonard, the company's chairman emeritus, and his wife, Evelyn, inherited the house after his mother passed away in 2004. Realizing it was time to freshen it up, the Lauders did so with great care—just new wiring and air-conditioning. "We wanted to respect the house," says Leonard. "I feel that we are still very young there. I look at it as our family house—it comes from the past and will go into the future." Much like Palm Beach itself.

Real estate tycoon Donald Trump's former wife Ivana Trump at Mar-a-Lago, 1986. *Previous page:* Palm Beach social figure Jim Kimberly (far left) and friends around his white sports car on the shores of Lake Worth, 1968. *Following pages:* American socialite, actress, and fashion icon C. Z. Guest with actor Peter Lawford at a Palm Beach polo ball, 1961.

Clockwise from top left: Jewelry designer Judith Murat with her husband, John Grubman; Palm Beach hostess Dolly O'Brien, circa 1960; Bill and Kit Pannill at a Society of the Four Arts tea, 2009; Nan and Tommy Kempner at the Wellington party, 1982; Lois Pope, Generoso Pope, and Cathie Lee Crosby at a charity ball, 1984; interior designer Joanne de Guardiola; first debutante party held in Palm Beach at the Everglades Club, 1956; Donald and Melania Trump attending a Red Cross ball at Mar-a-Lago; Slim Aarons with Mrs. Leverett Shaw at a party, 1960.

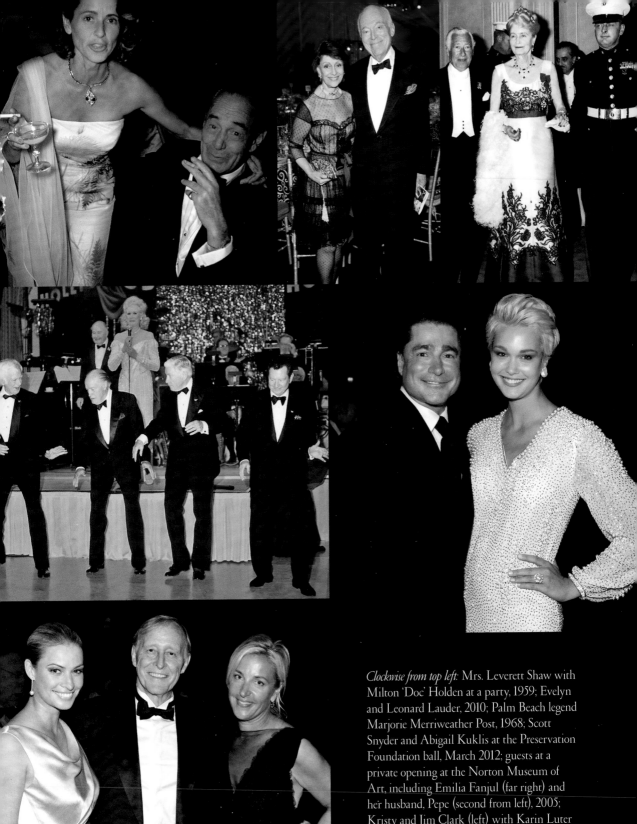

Clockwise from top left: Mrs. Leverett Shaw with Milton 'Doc' Holden at a party, 1959; Evelyn and Leonard Lauder, 2010; Palm Beach legend Marjorie Merriweather Post, 1968; Scott Snyder and Abigail Kuklis at the Preservation Foundation ball, March 2012; guests at a private opening at the Norton Museum of Art, including Emilia Fanjul (far right) and her husband, Pepe (second from left), 2005; Kristy and Jim Clark (left) with Karin Luter (far right) at the Palm Beach Zoo ball, 2011; Bobe Hope and friends dancing at a Breakers benefit with Dame Celia Lipton singing, 1991. *Following pages:* Pauline Pitt and Jerry Seay dancing together at Tommy Quick's birthday party; Woolworth Donahue and Mrs. Arturo Patino at the opening of the Colony Club, circa 1935. *Pages 98–99:* The nightlife scene at Michael R. McCarty's.

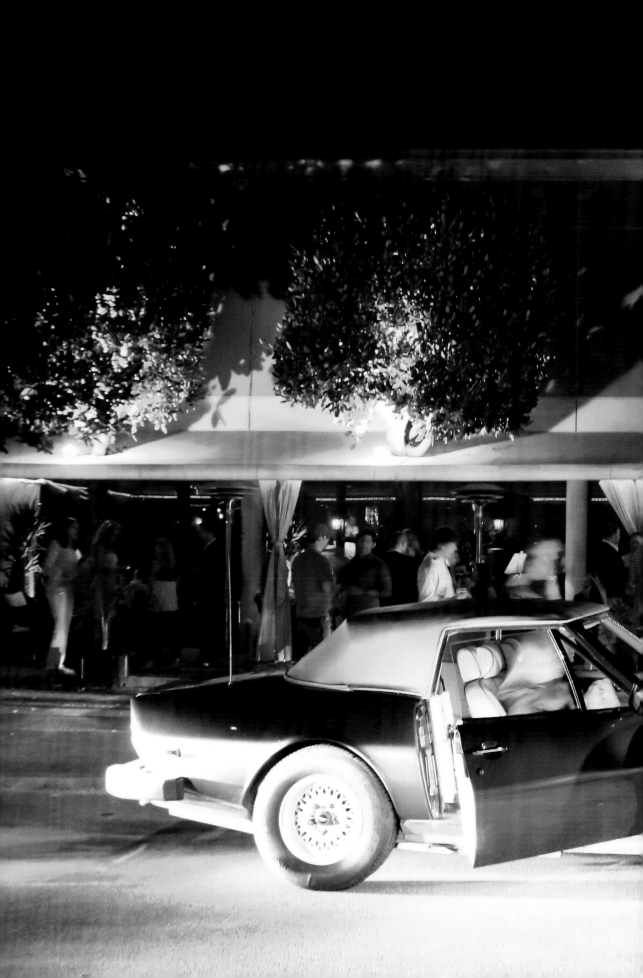

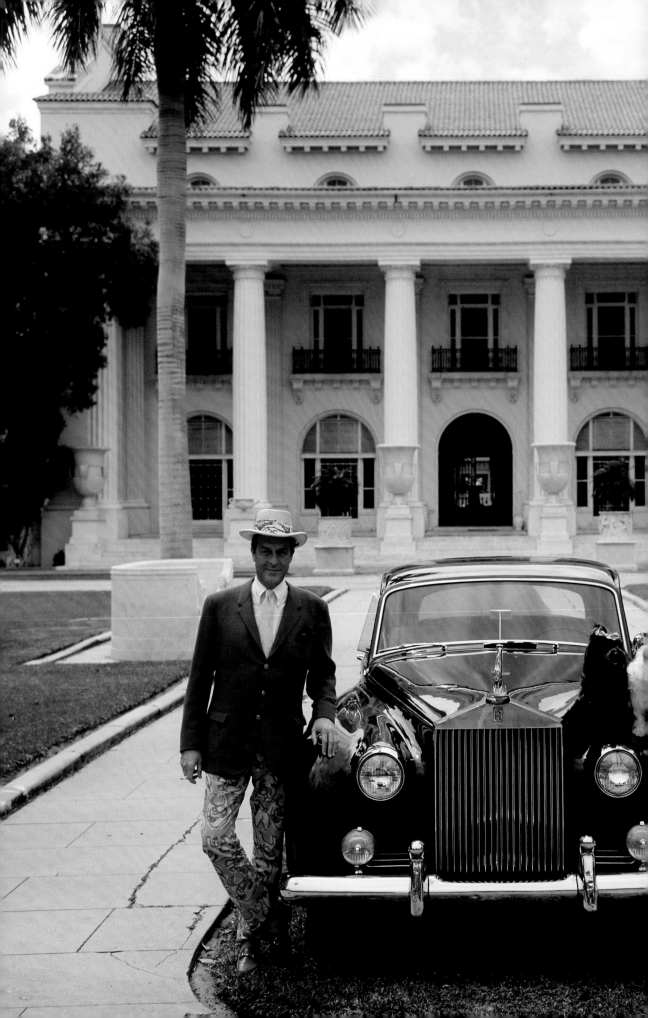

Palm Beach Style

Jackie [Kennedy] wore one of my dresses—it was made from kitchen curtain material—and people went crazy. They took off like zingo. Everybody loved them, and I went into the dress business.

Lilly Pulitzer

In the January 12, 1907, issue of *Palm Beach Life* under the rubric "Tastes and Toilettes," there appeared the following item: "The frock of crepe, voile, silk mousseline, chiffon cloth, and kindred materials made for wear during the heated season will now re-enforce [*sic*] a winter wardrobe in a most satisfactory fashion, especially if that winter is spent in Palm Beach."

Style has always been an important aspect of this most status-seeking of resort cities. During afternoon tea dances at The Breakers during the same period, women wore modest ankle-length or floor-length dresses and wide-brimmed sun hats. The men always wore suits (and hats, too, of course). At night, it would have been unthinkable for a gentleman not to don a white tie and tails.

Mr. and Mrs. Donald Leas outside the Flagler Museum in Palm Beach, 1968. *Following pages:* George Clarke at a Palm Beach party, 1955.

Linen was a favorite fabric. White and beige were the monochromes of choice, sometimes pale blue and pink. Every once in a while a trend would creep in: "Among the most fashionable plumage of the season is of the owl in natural colors," declared *Palm Beach Life* in its January 21, 1907, edition. Basic black? For widows only.

As time went on, and skirt lengths went up and down and up again, Palm Beach pretty much continued to dress for the occasion, whether it be a formal ball, a private dinner party, an afternoon stroll on Worth Avenue, or a polo match. While there was a "Palm Beach style," there wasn't a particular American designer associated with it—until, that is, Lilly Pulitzer.

Lilly is a legend and so is her story. She hails from a high-society collection of families (Bostwicks, McKims, and later Phippses), went to the Chapin School in New York City, and met the dashing Peter Pulitzer, grandson of the newspaper publisher Joseph Pulitzer. They eloped in 1950. Eventually, the golden couple (she was as lovely as he was handsome) settled in Palm Beach, where they each had spent many vacations, and started a juice stand—Peter owned some citrus groves—on Via Mizner, off Worth Avenue. Squeezing juices all day wreaked havoc on her wardrobe; orange and lemon stains on white piqué did not make for a pretty picture. Clever girl that she was, Lilly began designing sleeveless shifts in bold patterns and vivid colors—lime green, lemon yellow, and shocking pink. Soon, she gave up the juice stand and went into designing full-time. Women like Jackie Kennedy took such a liking to their "Lillys," as they were called, that they became wildly popular in the 1960s and '70s among the social set. Lilly herself became known as the Queen of Prep. To this day, Lilly Pulitzer is the most famous designer to come out of Palm Beach. She and Peter divorced in 1969 and she sold the company in 1984, but it exists under different ownership and is still strongly identified with Palm Beach.

What Lilly Pulitzer did for Palm Beach apparel, Stubbs & Wootton did for footwear. Its founder, Percy Steinhart, tells an entirely different story to Lilly's. Born in Cuba, Steinhart worked at Citicorp in New York City overseeing Latin American business. "They wanted me to travel 70 percent of the time, which didn't appeal to me," he says. When he visited Palm Beach (often), he noticed that within his inner circle the men were wearing velvet loafers (no socks), usually made by the British firms of New & Lingwood or John Lobb. "They had one of three embroidered insignias: a foxhound, a Prince of Wales plume, or a crown," he notes. Steinhart's flash of brilliance was to do a gentle take on the loafers. "I wanted to call the company Holden & Caulfield, but then it dawned on me that J. D. Salinger wouldn't be happy about that," he recalls. "I loved the idea of double vowels and double consonants; a friend of mine had a painting by George Stubbs and I liked the name Wootton." Voilà: Stubbs & Wootton, the brand, was born. Very *Jeeves & Wooster*, you might say. It's not a mass brand, but it's one that Palm Beachers,

Socialite Wendy Vanderbilt (right) with a friend wearing Lilly Pulitzer sun dresses, 1964. *Following pages:* The loggia leading to the central patio at Casa della Porta, a Maurice Fatio–designed home; actor George Hamilton sporting a light summer suit, circa early 1960s.

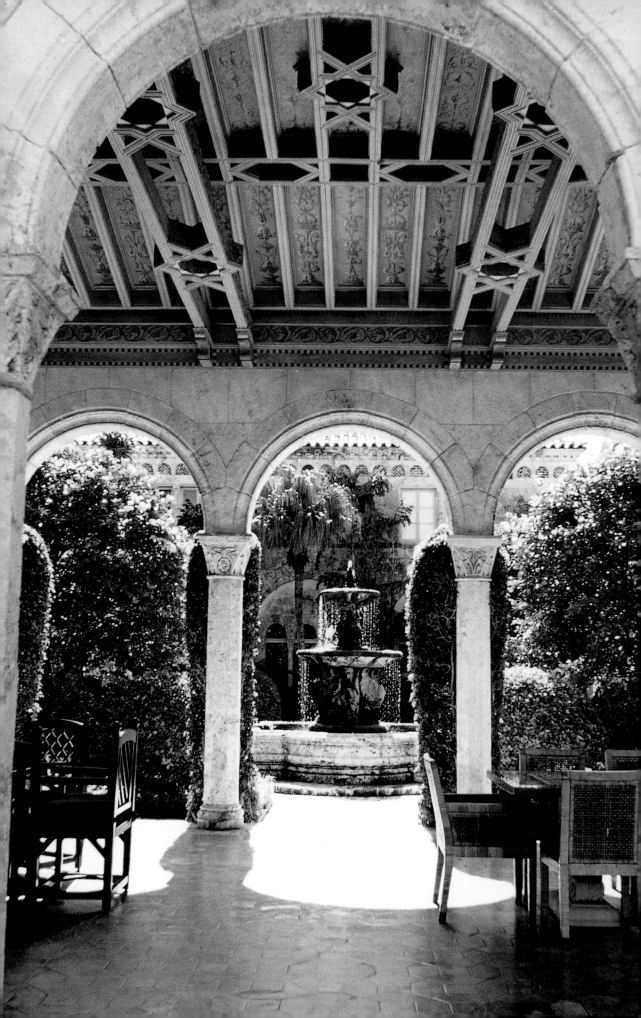

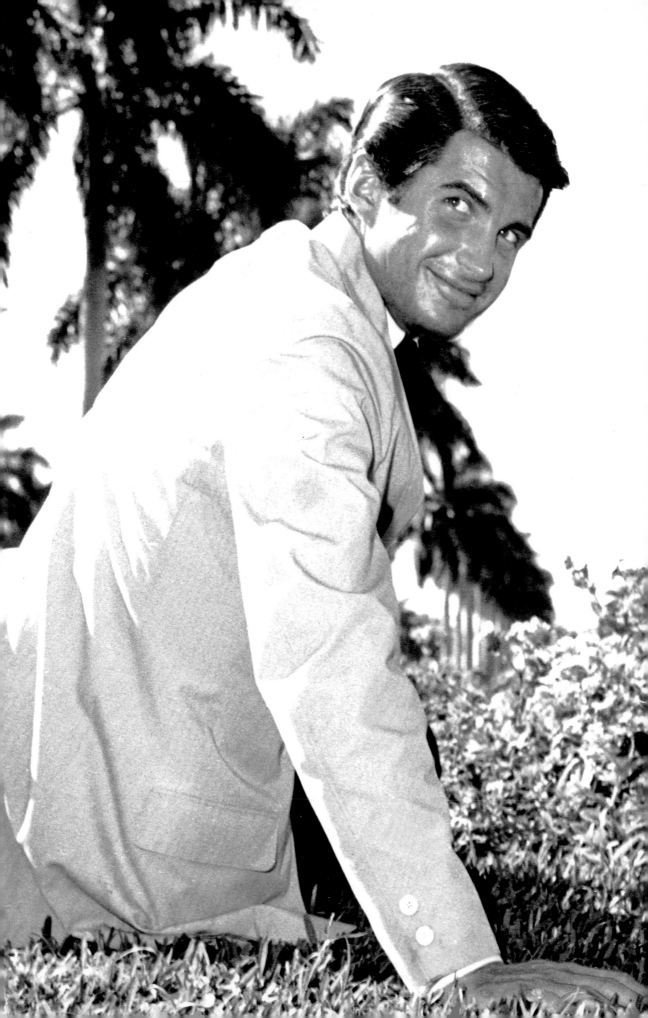

then Southamptonites, and others embraced immediately. Steinhart has two boutiques—one on Via Parigi in Palm Beach and one on Madison Avenue in New York. Pop-up shops may be in the future. Stubbs & Wootton clients are loyal and sometimes buy in bulk. Steinhart was particularly pleased—as well he should have been—when the renowned Italian fashion designer Valentino Garavani and his partner, Giancarlo Giammetti, stopped by the Madison Avenue store and bought a bunch of pairs as Christmas presents for their friends and family.

There are other staples of Palm Beach style, many of them available on Worth Avenue: the cashmere sweaters of Trillion; the patent-leather dress shoes at Maus & Hoffman; the jewelry of Seaman Schepps (especially the shell earrings); almost anything purchased at the home store of Mary Mahoney; and of course, the menswear departments at Brooks Brothers and Ralph Lauren. For men, the look is a warm-weather variation of preppy style: oxford cotton button-down shirts, cable-knit cashmere sweaters, madras plaid trousers or Nantucket Reds, and braided or needlepoint belts. Footwear: Sperry Top-Siders, Stubbs & Wootton slippers, or old Gucci loafers. For women: white cotton pants or an A-line skirt, a crisp linen blouse, a pair of loafers or Jack Rogers Navajo sandals, and perhaps (tread carefully here) a headband.

Ask Steven Stolman about Palm Beach style and he goes encyclopedic on the subject. Stolman, a part-time Palm Beacher, knows what he's talking about. For several years, he had an eponymous boutique on Worth Avenue showcasing the dresses and sportswear he designed from upholstery fabrics like chintz and toile. Here's how he sees it: "Palm Beach style is all about conformity—a regiment of blue blazers for men and bottle-blond hair for women. It's about being impeccably groomed yet decidedly nonchalant: sweaters tied over the shoulders, collars popped up, and sunglasses pushed into the hair. Breezy, casual, but also studied. It's frozen in time and, with a few exceptions, has absolutely nothing to do with current fashion. Indeed, it's anti-fashion and sticks out like a sore thumb in places like airports—other than Palm Beach International.

There are times when the vagaries of fashion dip ever so slightly into the Palm Beach vocabulary, such as the rage for certain colors like tangerine or the wearing of tunics or caftans, but anything too fashionable is an immediate buzzkill for the authentic Palm Beach look. Another important element is the WASP ethic of good legs, slim hips, and a sun-kissed face— whether natural or, ahem, acquired through other methods. Some consider a good face-lift to be as much an integral part of Palm Beach style as the right duds.

The key difference between Palm Beach style and preppy style is where they come from at their core. Preppy style is rooted in academia and sports, whereas Palm Beach style is a by-product of a life of leisure. I guess you could call it 'active sportswear for the inactive.' To me, Palm Beach style is embodied

Mr. and Mrs. Guillermo Aguilera at their Palm Beach home, 1970. *Following pages:* American polo player Winston Frederick Churchill Guest arriving at the Everglades Club for a game of tennis, circa late 1930s; cover model for a 2005 *Town & Country Travel* issue.

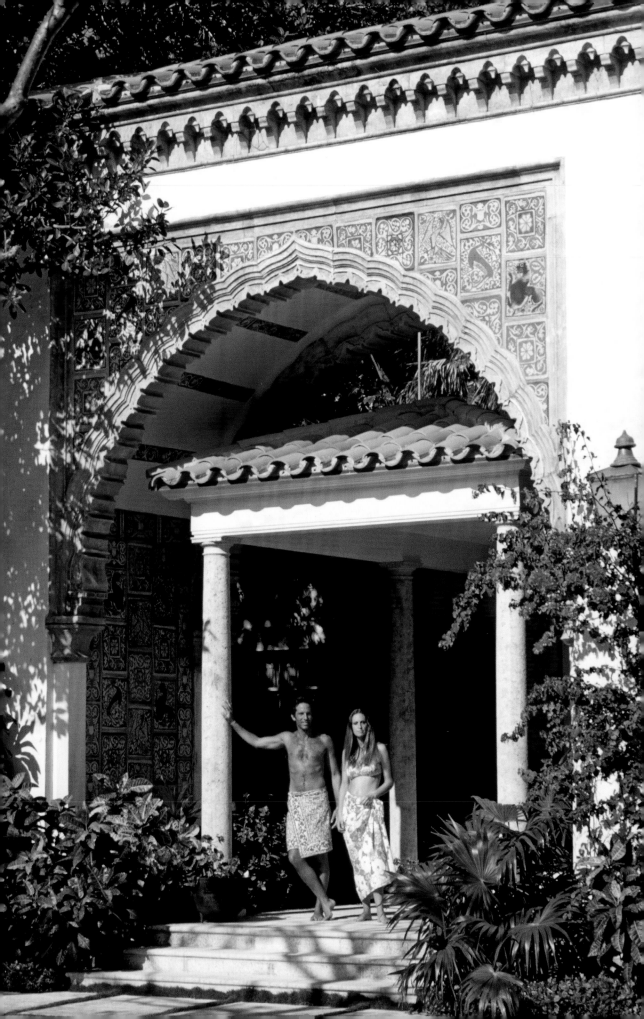

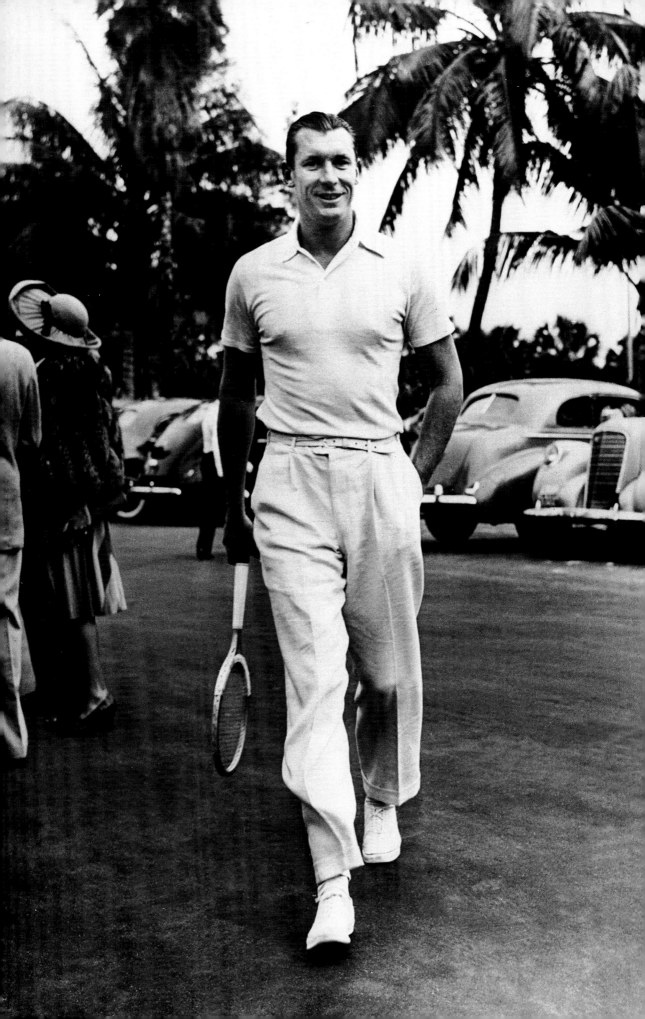

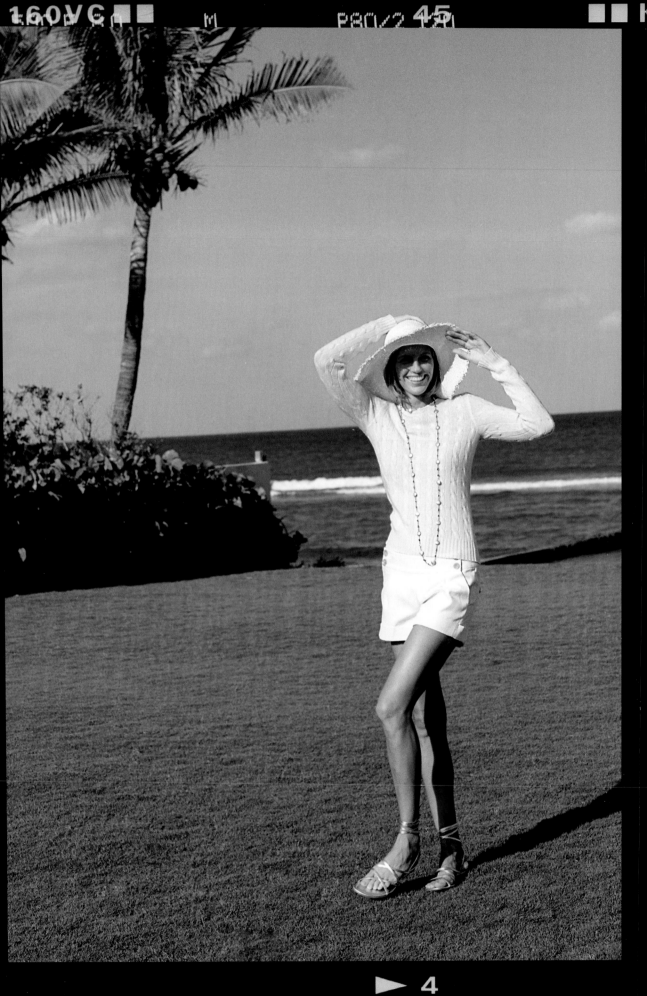

TOWN & COUNTR

MARCH 1983/$3.00

PERENNIAL
PALM BE

The Old Guard,
The Sporting Set &
New Internationals,
The Beautiful Girls &
Dashing Young Men,
The Exclusive Clubs &
Sumptuous Shops
That Make This
The Greatest
Little Beach Town
On Earth

The Privileges of
Personal Banking

The Gourmet Spud:
Flavor Is More
Than Skin Deep

Beauty Odyssey:
A Modern Greek Heroine
Returns to Her Ancient Past

Trinidad and Tobago:
The Undiscovered
Island Dream

The Free Library:
America's Endangered
Institution

The Palm Beach Look:
Mrs. Garrison du Pont Lickle

Clockwise from top left: Man clad in
a Trillion sweater; Mrs. Joseph A.
Neff dressed for a charity luncheon;
Mrs. Garrison duPont Lickle on
the cover of the March 1983 issue of
Town & Country; Helena Martinez
sporting a colorful dress; (from
left) Mrs. Charles Bird, Mr. and
Mrs. Winston F. C. Guest (C. Z.
Guest), and their son, Alexander,
1966; William E. Hutton III
taking a break on his scooter,
Town & Country magazine, March
1988; Lillian Crawford, the wife of
actor Lee Kinsolving, showing off
Palm Beach poolside fashion, 1970.
Opposite: Mr. and Mrs. Harry Loy
Anderson, ready for a motorbike
ride, 1970.

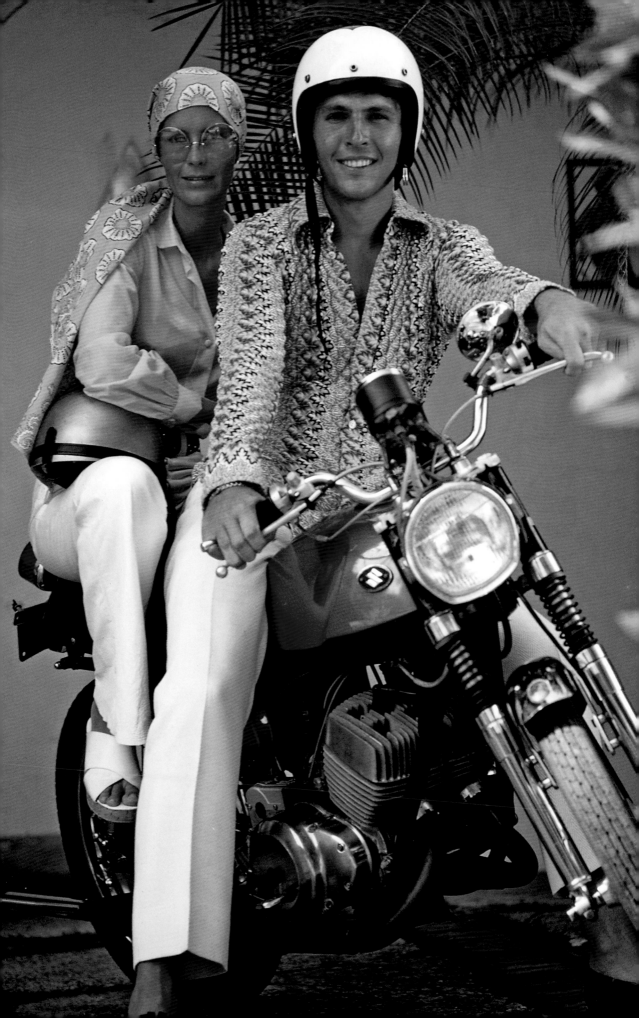

" *Whenever I have visitors coming for the first time, I take them to Worth Avenue at night—when it's at its most magical. When the shops are closed and the people are few, the lyrical beauty of Addison Mizner's Vias off the avenue really come to life.* "

BRIAN SAIPE
PROFESSIONAL ORGANIZER

" *From its roots more than a century ago, tiny Palm Beach has always lived large.* "

DARRELL HOFHEINZ
EDITOR, *PALM BEACH DAILY NEWS*

" *I love Lilly Pulitzer Rousseau's house. Everything she designs is a combination of joy and practicality. Her house reflects the same spirit.* "

JENNIFER ASH RUDICK
AUTHOR OF *TROPICAL STYLE*

" Living here is pretty amazing. You have beaches everywhere and we never get the winter blues. "

LILY HOLT
SHOE DESIGNER

" Lush, flamboyantly attired, and hospitable, Palm Beach exceeded its arch and quirky reputation. "

SIMON DOONAN
CREATIVE DIRECTOR OF BARNEYS
TRAVEL + LEISURE, OCTOBER 2008

Clockwise from top left: Flashy car parked in front of the Ralph Lauren boutique on Worth Avenue; facade of the Graff boutique; Charles Amory outside his flower shop on Via Mizner, off Worth Avenue, in 1972; Worth Avenue is the premier shopping destination in Palm Beach; Norbert Goldner of Café l'Europe; high-end designer stores on Worth Avenue; Porsche parked outside of Trillion.
Opposite: The Alexis Obolenskys strolling on Worth Avenue.

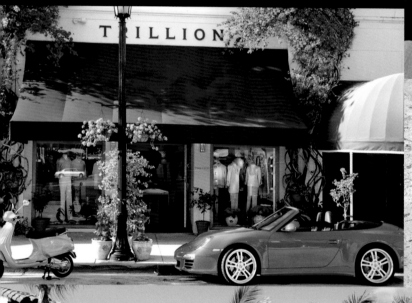

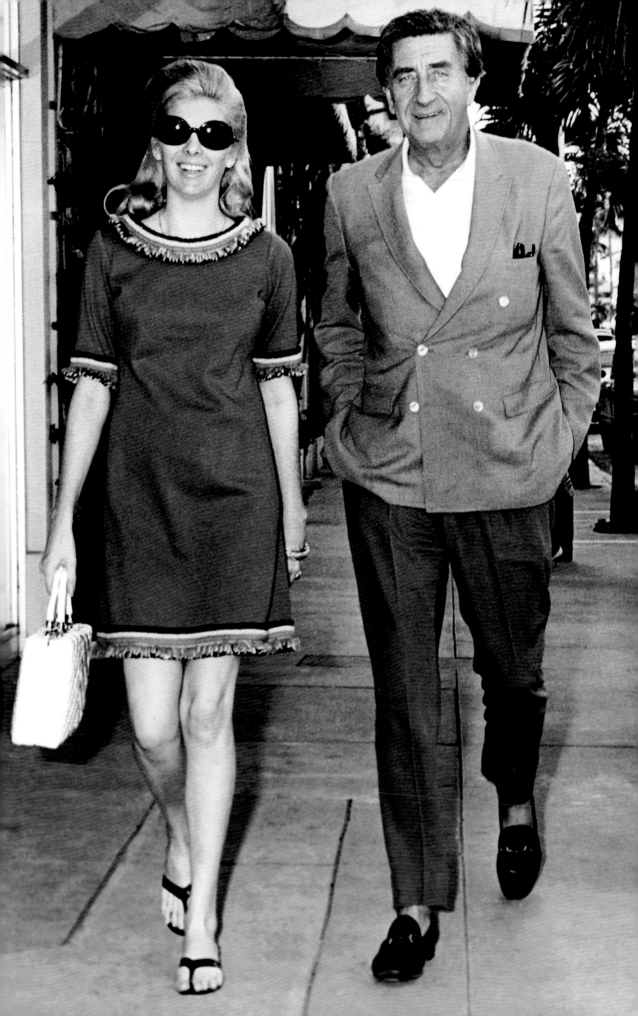

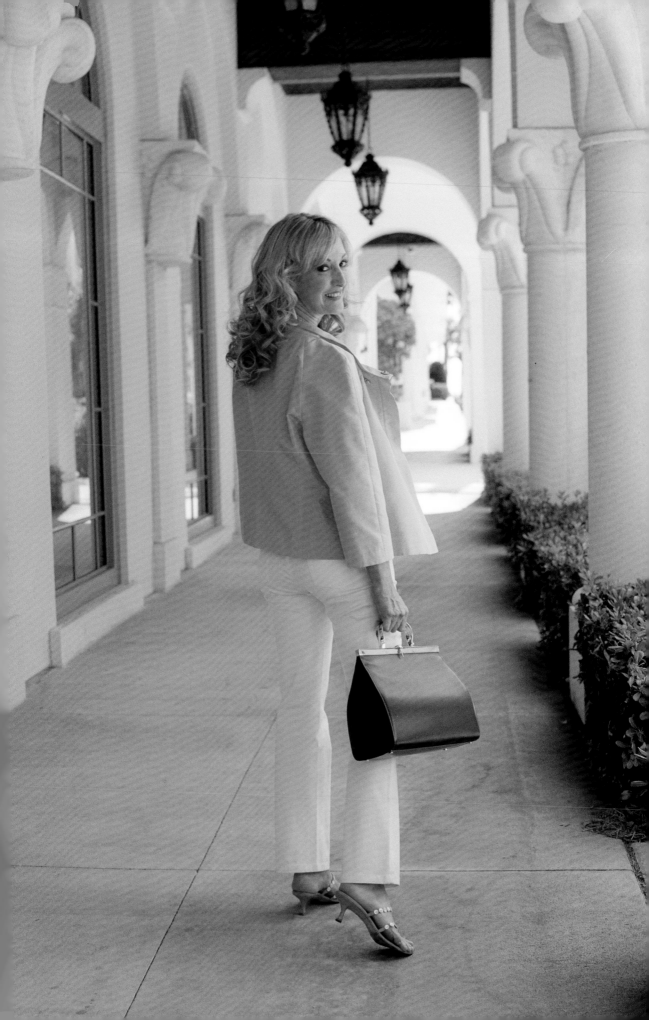

by two iconic Palm Beachers: socialite Pauline Pitt and the actor George Hamilton. The obvious aspects are extraordinary good looks and sunny dispositions, as well as appearing totally comfortable in their respective skins.

Missteps occur through anything or anyone trying too hard—jewelry that's too big (even in the land of glittering tiaras and skating-rink rings), faces that are too taut, or lips too plump. Nonchalance is such a big part of appearing authentically Palm Beach that aggressive fashion, sky-high heels, and studded-leather anything are immediate giveaways that one is from out of town. So are socks.

Just putting on a pink and green something—even from Lilly Pulitzer—isn't enough. It has to be the right pink and the right green... something like a combination of Bazooka bubble gum and a Granny Smith apple. It needs to grate on the nerves and border on garish to be accurate. Anything else looks reductive.

Palm Beach style can be overdone for exactly the same reasons it exists: because of its strict adherence to conformity. The lack of diversity—the stoic sea of blue blazers and sleeveless shift dresses and jangling gold bracelets—can actually be downright saddening, which is ironic given that so much of the recipe involves bright colors. Palm Beachers joke about the 'uniform,' but it's true." P.S. Unless you live in Palm Beach, don't try this at home.

Modeling Lilly Pulitzer designs, 1970. *Previous pages:* Dorothy Hearst aka Mrs. William S. Paley shopping on Worth Avenue, 1939; jewelry designer Laura Munder showing off a pink jacket.

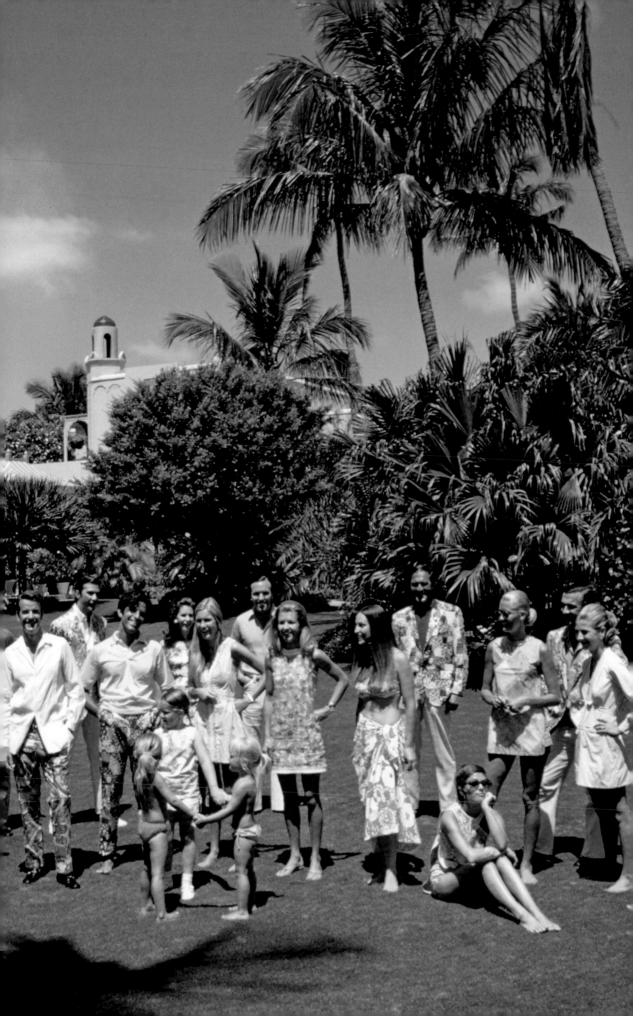

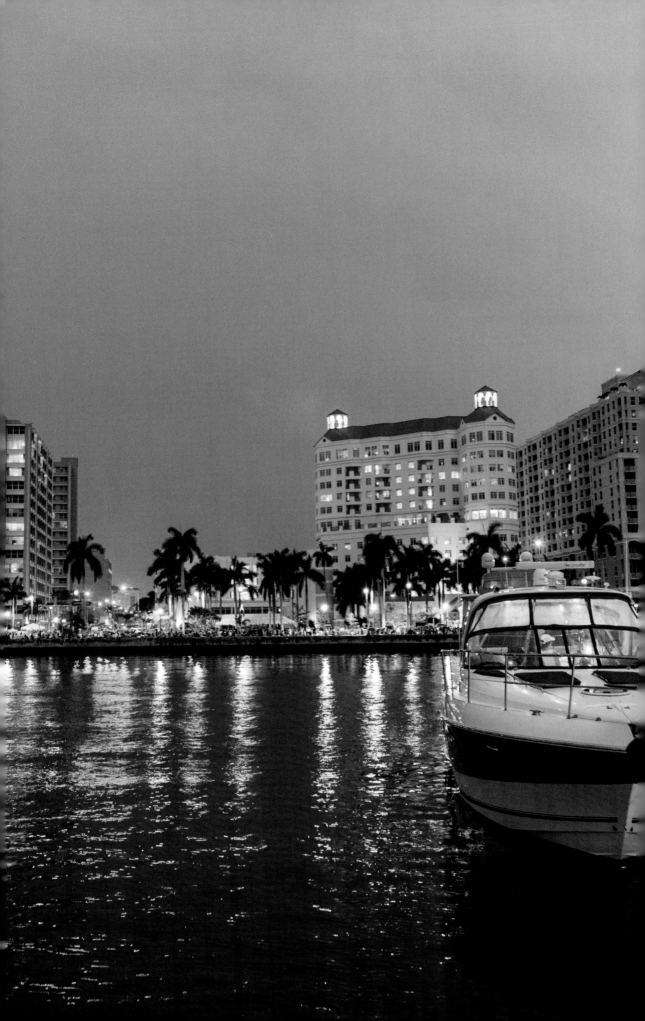

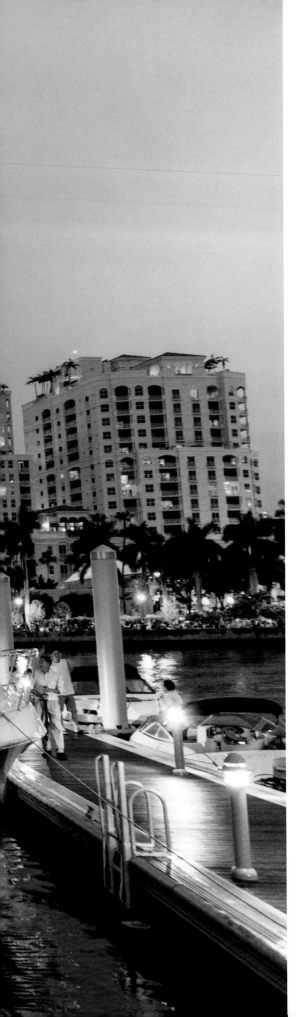

The Other Palm Beach

I like the wonderful view and the fact that I am directly on the water. I was able to buy the properties for a lot less than they would have cost in Palm Beach. Still, I'm very close and it's a lot less formal here.

Beth Rudin DeWoody, art collector and patron, commenting on West Palm Beach

There is Palm Beach, the island, a meticulously preserved Garden of Eden inhabited by the extravagantly rich and famous. While it's not exactly a gated community, it might just as well be. So private are its inhabitants, so grand its residences, so lofty are its privileges and offerings: luxury shopping on Worth Avenue, five-star hotels, chichi restaurants, towering condominiums with breathtaking ocean views, exclusive (in every sense of the word) clubs, and a supermarket that looks like a Ritz-Carlton with its very own sommelier presiding over the wine department. Then there is West Palm Beach, much larger, far less exclusive, more commercial, and more affordable. It is the anti–Palm Beach, if you will.

A dock in the Intracoastal Waterway in West Palm Beach, Florida.

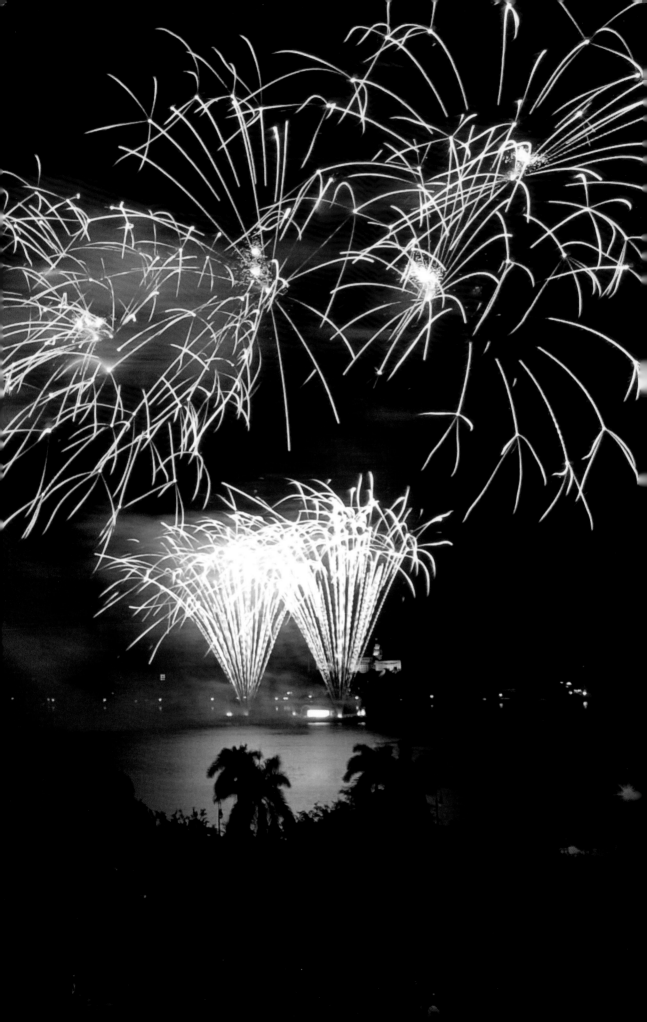

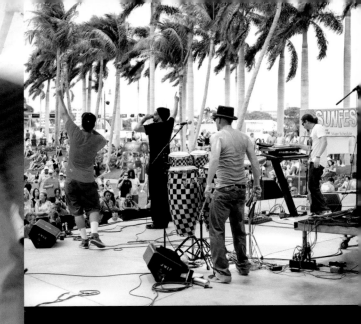

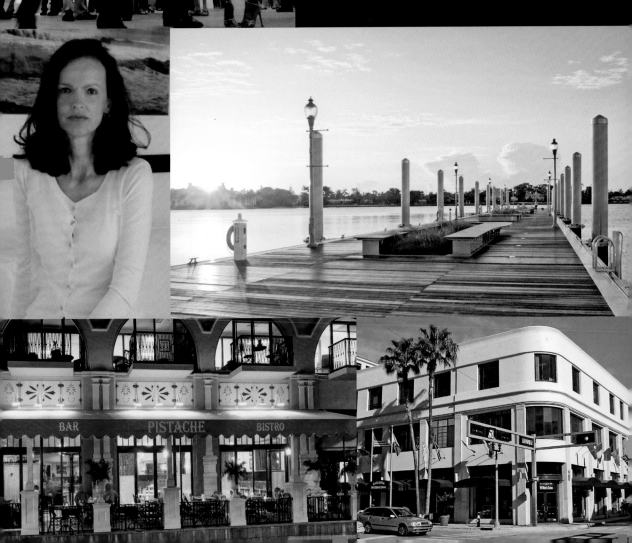

Clockwise from left: The proximity to Miami Beach, where Art Basel takes place every year, makes West Palm Beach attractive for the art crowd; performers at SunFest, which features over fifty music groups and a juried art show; West Palm Beach dock; West Palm Beach office building; exterior of the trendy Pistache restaurant; West Palm Beacher Bettina Von Hase. *Opposite:* Fireworks show during SunFest.

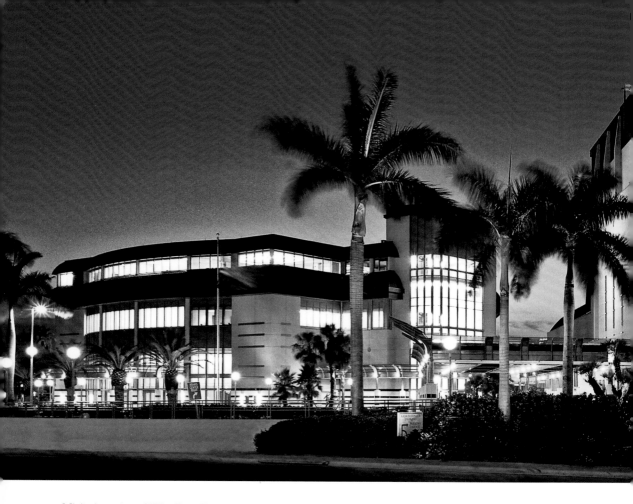

Nighttime view of West Palm Beach's Kravis Center for the Performing Arts.

WPB, as it is known, features an outdoor mall called CityPlace offering chains like Gap, Banana Republic, Barnes & Noble, and Restoration Hardware. Until CityPlace opened in 2000, the main shopping area was in and around Clematis Street, which is experiencing a revival owing to the profusion of bistro-like eateries and a lively outdoor market on Saturdays, selling everything from orchid plants to freshly baked French pastries and artisanal cheeses.

West Palm Beach's founder was none other than Henry Morrison Flagler, who created it in the 1890s as a spillover community to house employees working at the Hotel Royal Poinciana and the Palm Beach Inn (later renamed The Breakers). Today, West Palm Beach is the largest incorporated municipality in Palm Beach County and the oldest in all of South Florida.

Before the 2008 recession, WPB experienced a real-estate boom. One of its instigators was John Loring, then the design director of Tiffany & Co. Loring, a tall, courtly man, has been coming to Palm Beach since he was a child. But the thought of living on Palm Beach, the island, never crossed his mind—though something else did: West Palm Beach.

Here's how Loring tells it: "I was having lunch at the Everglades on a Sunday in 2003 and suddenly I decided to get in my car, cross the bridge, and see some open houses in

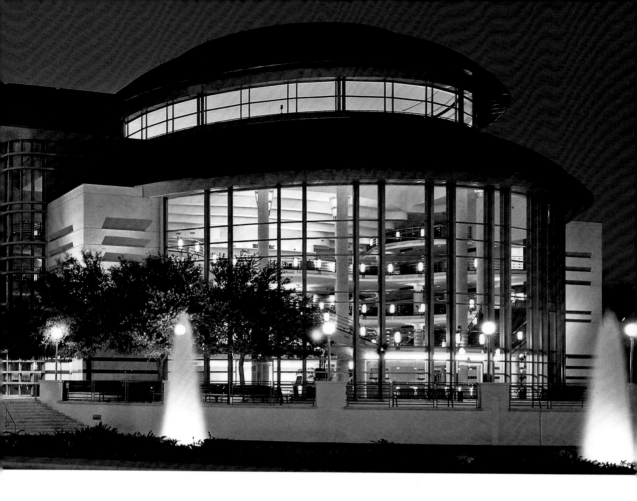

the historic sections." One in particular caught his well-trained eye. "It practically cost the price of a ham sandwich," he says. With that, Loring and other individuals—including Paige Rense, who was the editor of *Architectural Digest*—started creating their own little community of like-minded souls in West Palm Beach.

To many, Loring is the godfather of the West Palm Beach movement. Some of his friends blanched at the idea of buying in WPB. Others commended him: "When I told Pat Buckley [the late wife of William F. Buckley, Jr.]," Loring recalls, "she said, 'That's the most intelligent thing I've heard all summer!'" Asked about the condition of the house when he bought it, he answers, "Deplorable." It's most certainly not deplorable anymore, and Loring now lives there full-time.

Two of the people he convinced to move there are Michael and Eleanora Kennedy. He is a prominent trial lawyer and she is a trial consultant and a philanthropist (on the boards of the Central Park Conservancy and the Society of Memorial Sloan-Kettering Cancer Center in New York). Their cottage is small, cozy, and for them, a romantic retreat. They lovingly dubbed it Casa Can Do and turned the garage into guest quarters ("the Shack in the Back").

Clematis Street at night.

Eleanora becomes rhapsodic when talking about West Palm Beach: "I love its casualness; the three classes of people—rich, middle, and poor; the afternoon light on Dixie Highway; Clematis by night; the views of Palm Beach from the Intracoastal; not having to join a club to have fun with the kids; and how little one can spend here, not how much."

London-based art adviser Bettina von Hase traveled the world but never before came upon what she described in a 2010 British *Vogue* article as a "bolthole where I can relax, a place I can go to without having to fit in around others." For Bettina, West Palm Beach is far more real and less disconnected than Palm Beach, not to mention rather exotic by comparison to London. The proximity to Miami Beach, where Art Basel takes place each December; the music and culinary scenes; and the influx of international artists and writers are all part of the attraction. Then there's the house itself, which she found thanks to her friend, photographer Priscilla Rattazzi Whittle. One look at the charming one-story 1940s cottage and she knew she'd found the architectural equivalent of Mr. Right. "I experienced a *coup de foudre*," she wrote. "The kind, I might add, I've never felt for a man."

West Palm Beach, nonetheless, has a great deal to offer: a more bohemian and artistic flavor, culture (the Kravis Center

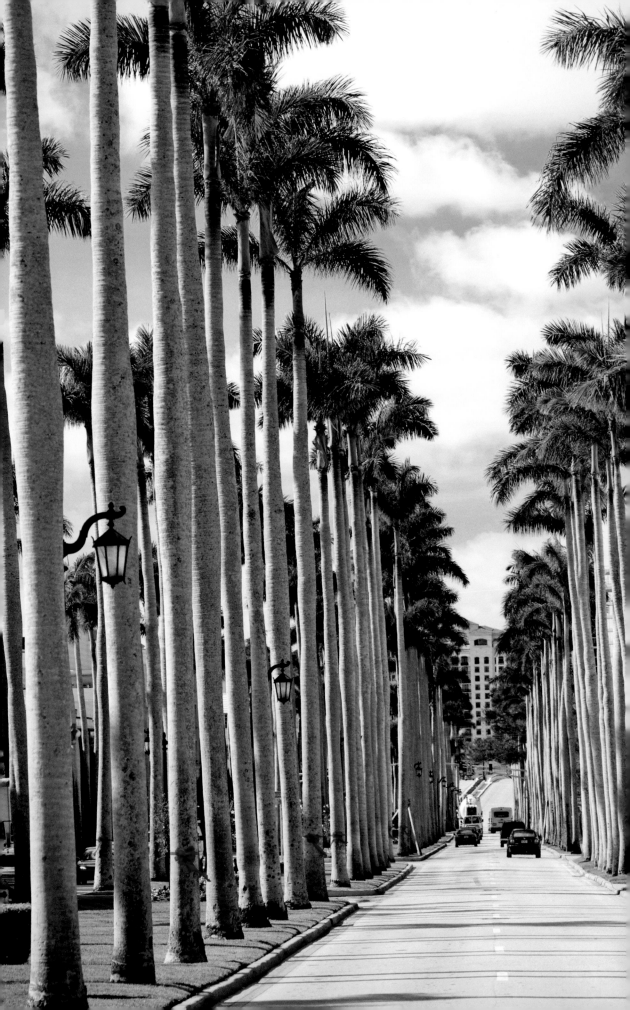

for the Performing Arts, the Norton Museum of Art, an annual music and art festival on the waterfront called SunFest), sports (the National Croquet Center—the largest croquet facility in the world), and boundless shopping opportunities for those looking for a deal (Antique Row on South Dixie Highway and a number of consignment and thrift shops for scavengers of all stripes). Moreover, there are some lovely historic neighborhoods to explore, such as El Cid, with its impressive mission-style and Mediterranean revival houses; Flamingo Park, originally a pineapple plantation and one of the highest points in the area; and Central Park, Northwest, and Old Northwood, all listed in the National Register of Historic Places. Plus, there's the million-dollar view of Palm Beach and the Intracoastal from Flagler Drive.

Royal Palm Way, the boulevard leading to West Palm Beach.

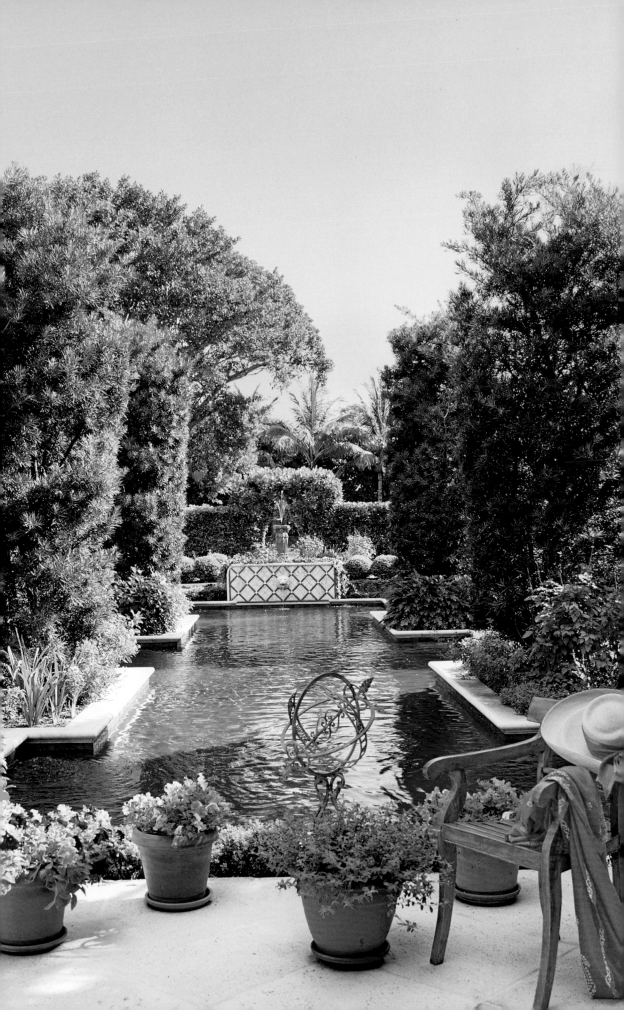

Fun in (and Out of) the Sun

WHEN TO GO

November through April is "the Season," but May, June, and October can be enjoyable as well. Avoid September, if possible (the height of hurricane season). Out of season, rates drop sharply in hotels, package deals are available, and you can get into any restaurant you want.

HOTELS

The undisputed queen of Palm Beach hotels is The Breakers (see Chapter 2: Splendor in the Sand). More intimate and romantic is the Brazilian Court (the Frédéric Fekkai salon and Café Boulud are there). It opened in 1926, originally designed by Rosario Candela, then expanded by Maurice Fatio, and recently re-landscaped by Mario Nievera. Popular and less expensive are the Colony Hotel (known for its cabarets) and the Chesterfield. On South Ocean Boulevard: the Four Seasons and the oddly named Omphoy; in Manalapan, the Ritz-Carlton.

SURREAL ESTATE

Almost every major real estate agency in Palm Beach offers house and condo rentals.

BEACHES

They're free and open to the public. All you need is a swimsuit and a place to park.

The pool and garden at the La Salona estate. *Following pages:* Oceanfront dining at the Ritz-Carlton hotel.

► 4

RESTAURANTS

PALM BEACH

Top tables (and the hardest to book) are at Buccan and the Palm Beach Grill (a higher-end branch of Houston's; try the tuna burger, key lime pie, and hot fudge sundae). Michael R. McCarty's has a genial staff and a patio that is lovely at lunch or dinner (order the fried green tomatoes and seek out its amiable and eponymous owner). Ta-boo, an old-line favorite, is right on Worth Avenue.

Newcomers: Imoto (a Japanese restaurant, next door to Buccan), PBCatch, and Table 26. For Francophiles, Bistro Chez Jean-Pierre (many claim it has the best French food on the island), Café L'Europe, and Café Boulud (the terrace is where you want to be). Italian cuisine can be found at Bice, Trevini, Renato's, and its little sister, Pizza al Fresco (dogs are welcome). Always reliable: any of the restaurants at The Breakers, including Echo, its off-campus, pan-Asian restaurant.

Beloved for breakfast and lunch: Hamburger Heaven and Green's Pharmacy (the crowd from St. Edward's across the street comes by after Sunday mass). A sign on Green's wall reads: "Beware: Attack Waitresses."

WEST PALM BEACH

The funky and fun Rhythm Café and Gulfstream Bistro (also a fish market). Howley's for pancakes. Tulipan for morning coffee and pastries. For Italian cuisine: Café Sapori, Vagabondi, and La Sirena. There are a slew of eateries and bars in CityPlace and on and off Clematis Street like Pistache and Grease Burger Bar.

NEWSPAPERS

The substantial *Palm Beach Post* and the gossipy *Palm Beach Daily* (aka "The Shiny Sheet").
To understand Palm Beach, you must read both.

GROCERY SHOPPING

The Publix on Sunset Avenue has valet parking and an extensive wine selection.
There's also Amici Market on North County Road.

The popular terrace at Café Boulud in the Brazilian Court. *Following pages:* The stately atmosphere on Worth Avenue.

SHOPPING

WORTH AVENUE

Recently spruced-up, this boulevard offers everything fancy and familiar: Ralph Lauren, Brooks Brothers, Hermès, Chanel, Ferragamo, Loro Piana, Bottega Veneta, Gucci, Pucci, Tory Burch, and Louis Vuitton. But there are also specialty boutiques on and off Worth like Fiandaca, Jennifer Garrigues, Lily Holt, Roberta Freymann, Diane Firsten, J. McLaughlin, Jennifer Miller, Calypso, Stubbs & Wootton, Tomas Maier, Mariko (costume jewelry), and a host of others. Saks Fifth Avenue and Neiman Marcus are across from each other. Sentimental standbys: Maus & Hoffman, Mary Mahoney, and Kassatly's jewelry. Take your pick (and have your credit card ready, please): Tiffany, Graff, David Morris, Bulgari, Kaufmann de Suisse, Laura Munder, Trianon/Seaman Schepps, Cartier, and Van Cleef & Arpels.

SOUTH COUNTRY ROAD

Closer to Worth Avenue are C. Orrico (specializing in Lilly Pulitzer), Chris Kellogg, Classic Bookshop, Lori Jayne Monogramming and More, and Blue Provence (great cheeses). Also, a number of consignment and thrift shops, including the humbly-named Church Mouse, Groovy Palm Beach Vintage, Lotus, Fashionista, and Razamataz (on Sunset). Don't forget The Shops at The Breakers with its terrific selection of boutiques and Guerlain Spa.

SOUTH DIXIE HIGHWAY

Along Antique Row: Floral Emporium, Lars Bolander, Mecox Gardens, Deco Don's, and others. Consignment and thrift shops galore. Handmade sandals: Palm Beach Sandal Co. on Florida Avenue.

ROYAL POINCIANA WAY

Tropical Fruits (best key lime pie on the island), Island Home, Evelyn and Arthur (for the senior set), Sprinkles, Palm Beach Bookstore, and Main Street News. House of Lavande, on the same strip as the Palm Beach Grill, has wonderful vintage jewelry.

MALLS

CityPlace and the much larger Palm Beach Gardens.

CULTURE

There's plenty of it: The Raymond F. Kravis Center (including the Palm Beach Opera), the Norton Museum of Art (the largest in Florida), the Society of the Four Arts, the Palm Beach Historical Society, and the Preservation Foundation of Palm Beach—all of them have terrific and interesting programs and exhibitions.

GALLERIES

There are many in both Palm Beach and West Palm Beach. Mentioned most by insiders: Wally Findlay, Liman, Gavlak, Arcature, and Holden Luntz.

POLO

Going strong at Wellington's 200-acre International Polo Club in season.

FAMILY ENTERTAINMENT

The charming Palm Beach Zoo in Dreher Park and the South Florida Science Museum are a must for both kids and adults.

NOT TO BE MISSED

The Flagler Museum on Cocoanut Row. Formerly known as Whitehall, Henry Morrison Flagler had it built in 1902 by John Carrère and Thomas Hastings as a wedding gift for his third wife, Mary Lily Kenan Flagler. Designated as a National Historic Landmark, the Beaux-Arts-style manse became a symbol of Gilded Age prosperity. It was constructed during the same era as several of the summer "cottages" in Newport, Rhode Island; Hearst Castle (San Simeon) in California; and Villa Vizcaya in Miami. Many of the seventy-five rooms have been restored and the grounds are impeccably manicured and be-flowered. On display is Flagler's own private railcar. All worth seeing. Docent and audio tours are available. www.flaglermuseum.us

Acknowledgments

Palm Beach, though tiny, is a complicated, multi-layered island. I am indebted to many who helped me navigate the waters as well as dry land, starting with Steven Stolman. If it weren't for Steven, my husband and I wouldn't have our little toe-hold in Palm Beach, or have met as many people as we have. He not only loves the place, but has steeped himself in its history. John Loring, the unofficial mayor of West Palm Beach, gave me his time and his intelligence (both are precious commodities). Others who paved the way and opened doors for me include Burt Minkoff, Annette Tapert, Helena and Roman Martinez, Leonard Lauder, Percy Steinhart, Laura Pomerantz, Tommy Quick, Pauline Pitt, Adrienne Vittadini, Emilia Fanjul, Priscilla Rattazzi Whittle, Ward Landrigan, Ashley Schiff, Eleanora Kennedy, Bettina Von Hase, Ellen Graham, Gigi Mahon, Jennifer Ash Rudick, Simon Doonan, John Mashek, Scott Moses, Beth Rudin De Woody, Jennifer Garrigues, Joanne and Roberto DeGuardiola, Jorie Butler Kent, Ervin S. Duggan, Melinda Hassen, Debi Murray, Jacqueline Weld Drake, Billy David, Scott Yetman, Ron Hatcher, Gary Karel, Carrie Bradburn and the late, great Lucien Capehart.

What sparked this book were two things: first, an article I researched on The Breakers, which is now Chapter 2. Everyone at this grand and historic hotel knocked themselves out for me, especially Paul Leone, David Burke, Shari Mantegna, and the estimable James Ponce. The second was a presentation I gave at the Society of The Four Arts on the long-standing relationship between Palm Beach and *Town & Country* (I was then the magazine's editor in chief). Thank you Molly Charland and Nancy Mato.

To those I interviewed who ended up on the cutting room floor, my apologies.

To everyone at the Regency, Debi and Bob above all, thanks for taking care of us on our sporadic trips.

To my colleagues at Assouline, *merci beaucoup* for letting me do a third book in this series. It's been a pleasure.

Finally, to my husband, Colt, who read every word and looked at every image many times over: It was a thankless job but I thank you anyway.

The publisher would like to thank the following individuals for their contributions: All World Vintage Photos; Myles Ashby and Michael Van Horne at Art + Commerce; Thierry Beaud; Jill Birschbach and Wendi Hammock at Getty Images; Carrie A. Bradburn; David Carson, Andy Frame, Tracy Kamerer, and Susan Swiatosz at the Flagler Museum; Lucien Capehart; Patrick Crowley; Dorothy Curry; Baby Davidoff; Aliénor de Foucaud; Christine DiRocco at the Ritz-Carlton; Ashley Douglass at the Kravis Center; Miki Duisterhof; Oscar Espaillat and Joe Maloney at Corbis; Samantha Goldsmith at the Estée Lauder Companies Inc.; Jeff Goldstein at Verdura; Rhona Graff; Celia Guevara at Best Buddies International Inc.; Claudia A. Harden at the Palm Beach Zoo; Paul Hogroian and Tomeka Myers at the Library of Congress; Rob Kinmouth; Angela Lastorino at Martin; Claudia Lebenthal and Justin Stuart Rose at Trunk Archive; Stephen Leek; Kelly Leyden and Shari Mantegna at The Breakers; LILA Photo; Suzy Maroon; Kellan Marcum of the City of West Palm Beach; Patrick Montgomery; Debi Murray at the Historical Society of Palm Beach County; Alex Anthony at the Norman Parkinson Archive; Karen Pasternack; Julia Peters at the Zimmerman Agency; Lee Radziwill; Kim Sargent; Joan Sargent; Nickolas Sargent; Julie Skarratt; Courtney Smith at Graff Palm Beach; Melissa Sullivan; Gwyn Surface at *The Palm Beach Post*; Lars Totterman; Melania Trump; Alexandra Warder; Lindsey White at the Society of the Four Arts; Priscilla Rattazzi Whittle; Lesley P. Williams at *Town & Country* magazine; Belen Woods at the Downtown Development Authority; Susan C. Wright at Sotheby's International Realty; Tatiana Van Zandt; and Lise Valeur-Jaques.

Nicki de Gunzburg, Mrs. Alistaire Mackintosh, Mrs. John Barry Ryan, and Duke Fulco di Verdura gazing out from a tree in Palm Beach, 1934.

Photo Credits